PARIS

100枚レターブック

season paper
collection

PARIS-100 Writing & Crafting Papers : Season Paper Collection

はじめに

『100 枚レターブック』は、1 枚ずつ切り離して使える紙を 100 枚収録した本です。

真っ白なつるつるの紙・クリーム色のざらざらの紙・茶色いクラフト紙という、色や質感の違う 3 種類の紙で、50 柄 ×2 枚＝ 100 枚の便せんを収録しています。

「シーズン・ペーパー・コレクション」は、パリで大人気の文房具ブランド。繊細で上品、でもどこか遊び心のあるデザインのノートやカードが、日本の雑貨店でも話題を呼んでいます。

1 枚ずつ異なる絵柄や、さまざまな幅の罫線・スペースなど、思わず手紙を書きたくなるデザインは、「書く楽しさ」にこだわったブランドならでは。そんな、紙もの好きの心をくすぐる紙を 1 冊にまとめました。

便せんとして使うのはもちろん、お気に入りの 1 枚を額に入れてインテリアとして楽しんだり、封筒・ぽち袋などの紙もの作りにも使えます。四つ折りにした紙がぴったり入る封筒（P8- 大）の型紙や、手紙を書くのが楽しくなる、横書きの手紙のマナーなども掲載しました。

使い方はアイデア次第。その日の気分や贈る相手に合わせて、さまざまに楽しめる 1 冊です。

パイ インターナショナル編集部

使用上の注意

- ページをしっかり開き、ゆっくり引っ張るとよりきれいにはがれます。
- 筆記用具によっては、インクがにじむことがあります。
- 本書掲載の型紙で作成した封筒は、郵送用には使用できません。

Foreword

PARIS - 100 Writing & Crafting Papers : Season Paper Collection contains 100 sheets of paper to cut out and use. The array includes 50 designs, two sheets of each, printed on a mix of paper stock in three colors/textures: white and silky smooth, cream colored with a rougher finish and brown craft paper.

Season Paper Collection is a brand of stationery, loved by Parisians. Their notebooks, cards and other items, in delicately refined yet subtly playful designs, are now a talking point in a variety of Japanese stores too. Individually patterned sheets and different line spacing options make letter-writing irresistible, as one would expect from a brand dedicated to the joy of writing. With *PARIS - 100 Writing & Crafting Papers : Season Paper Collection,* these designs, made to tickle the fancy of true paper lovers, have been gathered into a handy single volume.

As well as using the sheets for writing, try placing your favorite designs in frames to add a fun touch to interiors, or making items such as envelopes or small bags. Also included are a pattern for an envelope that will fit a sheet folded in four (p8 - Large) perfectly, and tips for writing on horizontal format to help you get the very most out of letter-writing.

Have fun with this book to match your mood of the day or the recipient of your letter: the only limit is your imagination!

The editors
PIE International

Notes

🌸 Open pages out wide and pull gently to remove neatly.
🍃 Ink from some writing implements may run or spread.
🍂 Envelopes made using the patterns provided are not suitable for posting.

profile
プロフィール

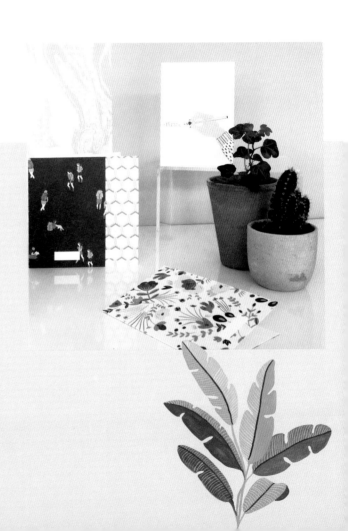

「シーズン・ペーパー・コレクション」は、テキスタイルデザイナーのジュリー・コスタズとメリッサ・ル・ヴァゲレズによる文房具ブランドです。ふたりが出会ったのはパリにあるインダストリアルデザインの国立学校。イラストをこよなく愛し、すっかり意気投合した彼女たちは、2012年に、ごく自然ななりゆきで一緒にブランドを立ち上げることになりました。

パリ郊外の町モントルイユのアトリエで生み出されるカードやノート、メモパッドやカレンダーは、すべて彼女たちが丁寧に手描きしたモチーフをもとに作られたもので、鉛筆やペン、絵の具など異なる画材と手法で描かれる絵柄は、いろいろな表情を見せてくれます。ヨーロッパ産の木材を使った紙や、植物性インクなど、環境に配慮した素材選びにもこだわっています。

ひと目見て「シーズン・ペーパー・コレクション」のものとわかる、繊細でポエティックなイラストは、パリジェンヌたちの心をつかみ、今ではフランス各地のセレクトショップや雑貨店で、彼女たちのアイテムを見つけることができます。

ペンを取るのが楽しくなる美しい文房具にとどまらず、お部屋を素敵に飾ってくれるポスターや、かわいいイラストと一緒にお出かけできるトートバッグなど、「シーズン・ペーパー・コレクション」の世界はどんどん広がっています。

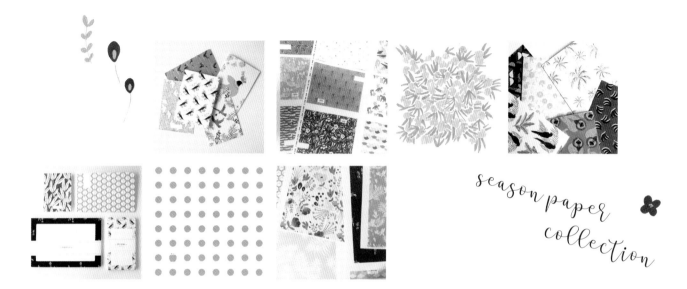

Season Paper Collection is a stationery brand created by textile designers Julie Costaz and Mélissa Le Vaguerèse. The pair met at l'École Nationale Supérieure de Création Industrielle in Paris. They clicked immediately and, due to their shared love of design, started their own brand, which launched in 2012. The cards, notebooks, memo pads and calendars, designed at their studio in Montreuil, in the suburbs of Paris, are all created based on motifs carefully hand-drawn by the pair themselves. Made using pens, pencil, paint and a range of techniques, the designs vary in appearance. Concern for the environment is also reflected in their choice of materials, which includes paper made from sustainable forests and vegetable-based inks.

The delicate, poetic illustrations that make Season Paper Collection products instantly recognizable have captured the hearts of Parisiennes and today their items can be found in boutiques and lifestyle shops throughout France.

The world of Season Paper Collection is steadily expanding and includes not only beautiful stationery that makes writing a pleasure, but posters to brighten rooms, and tote bags so that fans can take their favorite illustrations with them wherever they go.

season paper collection

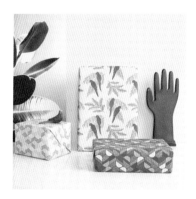

封筒・ぽち袋の作り方

本書に収録した紙を使って、封筒やぽち袋などを作ることができます。
繰り返し使えるよう、型紙をコピーし、厚紙で作るのがおすすめです。

1 型紙を実線で切り取る。
使いたい紙の表面に型紙をのせ、
えんぴつなどで型を取り、
カッターで切り取る。

2 封筒：①〜④の順に山折りし、
のりしろ○の裏面をのりづけする。

3 ぽち袋：A〜Dの順に山折りし、
のりしろ▲、のりしろ■の
順に裏面をのりづけする。

Making envelopes

Use the papers provided in this book to make envelopes large, small and mini. In order to be able to use the templates over and over again, we recommend copying them onto sheets of heavy paper.

Directions

1. Cut out the template along the solid lines.
2. Lay the template on the outside of the paper of your choice. Trace the outline of the template in pencil or pen onto the paper. Cut along the lines with a cutting knife and remove the envelope to be.
3. For stationery envelopes: Fold tabs 1-4 (in that order) back in "mountain folds" and apply glue to the back side of the glue tabs marked ○. For mini money envelopes: Fold tabs A-D (in that order) back in "mountain folds" and apply glue to the glue tabs marked ▲ and ■ (in that order).

封筒 *envelope*

表　　裏

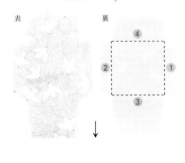

ぽち袋 *mini envelope*

表

裏

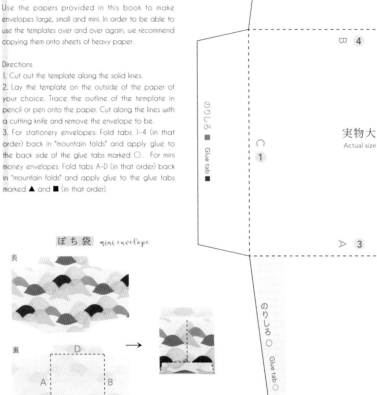

▼ Glue tab　◀ のりしろ

のりしろ
■
Glue tab

4 ③ 4

1 ○ ①

2 D ②

実物大
Actual size

▷ 3

のりしろ ○
Glue tab ○

のりしろ ○
Glue tab ○

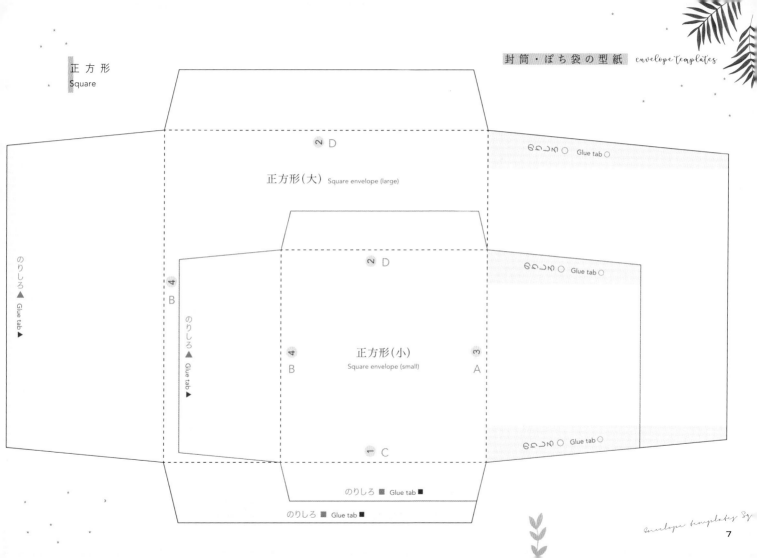

正方形
Square

正方形（大）Square envelope (large)

正方形（小）
Square envelope (small)

② D

③ A

④ B

① C

Glue tab ○

Glue tab ○

Glue tab ○

のりしろ ▲ Glue tab ▲

のりしろ ▲ Glue tab ▲

のりしろ ■ Glue tab ■

のりしろ ■ Glue tab ■

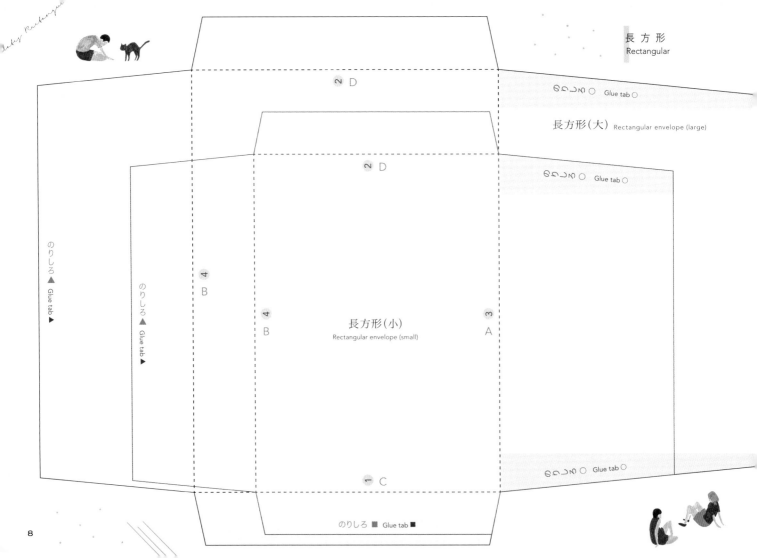

長方形（大）Rectangular envelope (large)

長方形（小）
Rectangular envelope (small)

２ D

３ A

４ B

１ C

Glue tab ○

のりしろ ▲ Glue tab ▲

のりしろ ■ Glue tab ■

折り手紙 *folded letter*

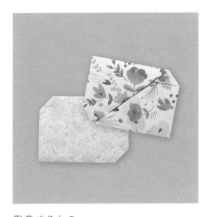

用意するもの
本書収録の紙 … 1枚

What you'll need:
One sheet of paper from this book

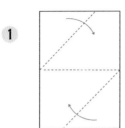

1

文章が書かれた面を上にして、紙を半分に山折りし、中央の折り目に合わせるように上下を斜めに山折りにする。

Place the side of the paper with the writing on it face upwards, fold the paper in half, and then fold the top and bottom diagonally aligning them with the center fold line.

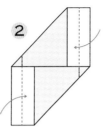

2

図のように山折りにする。

Fold as shown in diagram.

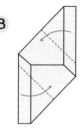

3

図のように山折りにする。

Fold as shown in diagram.

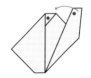

4

● 部分を入れ込む。

Insert the corner marked ● into folded corner.

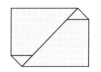

5

反対側も同じようにする。

Repeat on the other side of the paper.

Letters 書く

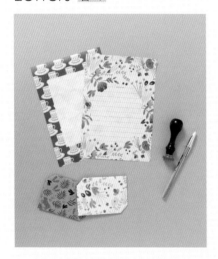

Gifts 贈る

Interiors 飾る

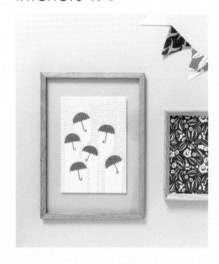

さまざまな幅の罫線やスペースなど、手紙を書くことにこだわったデザインは、シーズン・ペーパー・コレクションならでは。

Designs that inspire you to write letters feature ruled lines and spaces of various width that are unique to Season Paper Collection.

本書収録の型紙を使って、サイズ違いで作れるぽち袋や封筒。小さな贈りもののラッピングにもぴったり。

Little bags and envelopes that can be made in different sizes using the paper patterns in this book are perfect for wrapping small gifts.

お気に入りの紙を額に入れて飾るだけで素敵なインテリアに。好きな形に切ってガーランドにするのもおすすめ。

Just frame your favorite print to add a nice decorative touch to any interior, or cut into shapes to make a pretty garland.

手紙の書き方

基本的なマナーを知っていれば、手紙を書くことはもっと楽しくなります。あとは一語一語、心をこめて。

宛名 ——— 三芳恵美様

頭語 ——— 拝啓

時候のあいさつ ——— うららかな春の日差しが感じられる季節となりました。いかがお過ごしでしょうか。

さて、先日は素敵なパリのおみやげをありがとうございました。

クッキーと紅茶は、早速おいしくいただきました。ふたりで一緒に行ったパリ旅行を思い出して懐かしい気分になりました。

久しぶりにどこかでお会いしませんか？近いうちにこちらからご連絡しますね。

結びのあいさつ ——— まだ肌寒さの残る日もあります。くれぐれもご自愛くださいませ。

結語 ——— 敬具

日付 ——— 3月10日

署名 ——— 大塚みなみ

＊インクの色は黒かブルーブラックが基本。絶縁や不幸な意味合いを持つ赤、緑、グレーは避けましょう。
＊横書きは親しい相手への手紙に適しています。自由にアレンジして楽しみましょう。

1 前文

あらたまった場合を除いて、「拝啓」などの頭語を省略しても構いません。時候のあいさつは頭語から1字分空けるか、改行して1字下げて書き始めます。

2 主文

「さて」「ところで」など、本題に入るきっかけの言葉となる起語を入れ、手紙の目的・用件を書きます。

3 末文

結びのあいさつとして、相手の健康を願う言葉や、用件をまとめる言葉を述べます。
結語は頭語と合わせます。「拝啓」には「敬具」、「前略」には「早々」「かしこ」など。結語の後は1字空けます。

4 後付け

手紙を書いた日付、署名を入れます。日付は行頭1、2字分空けて算用数字で書き、署名は行末より1字空けて書きます。

index

インデックス

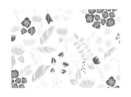

Jardin / Garden
ガーデン

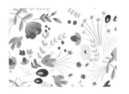

Fleurs folk / Folk flowers
フォークロア・フラワー

Plongeuses / Diving
ダイビング

Baies / Berries
木の実

Mésanges / Chickadees
シジュウカラ

Sapins / Fir trees
もみの木

Chou / Cabbage
キャベツ

Landscape
ランドスケープ

All the mountains
山々

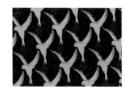

Envol / Taking flight
飛び立ち

Aqua
アクア

On the sea
海の上

Cubes
キューブ

Ciel de Paris / Paris sky
パリの空

Floraison / Flowers in bloom
満開の花

À bicyclette / Cycling
自転車で

Patchwork
パッチワーク

Sur la branche /
On a branch top
枝の上で

Les inséparables /
Inseparable
離れられないふたり

Promenade / Stroll
散歩

Après la pluie / After rain
雨上がり

Seaside
海辺

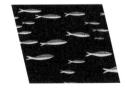

Sardines
いわし

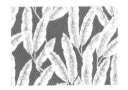

Plumes / Feathers
羽根

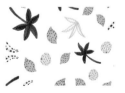

Tutti Frutti / Tutti-frutti
トゥッティ・フルッティ

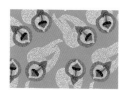

Mandrilles / Mandrills
マンドリル

Phares / Lighthouse
灯台

Banana
バナナ

Nageurs / Swimmers
泳ぐひと

Icecream / Ice cream
アイスクリーム

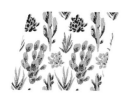

Cactées / Cacti
サボテン

Jungle
ジャングル

Wax
ワックス

Bataille / Snowball fight
雪合戦

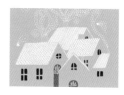

Night lights
夜の明かり

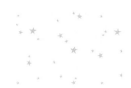

Stars
星

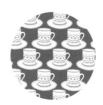

Cup of tea
ティーカップ

Allumettes / Matchsticks
マッチ

Dans les airs /
Skyward bound
空へ

Randonneurs / Hikers
ハイキング

Jardin d'hiver /
Winter garden
冬の庭

Running fox
走るキツネ

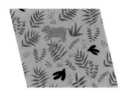

Yosemite
ヨセミテ

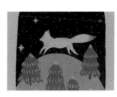

Renard / Fox
キツネ

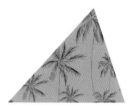

Palmeraie / Palm trees
椰子の木

À la main / Handwritten
手書き

Travel
トラベル

Paris, je t'aime /
Paris, I love you
パリ、ジュテーム

Faïence / Pottery
陶器

Parrots
オウム

Les motifs

PARIS 100枚レターブック
Season Paper Collection

2017年11月15日　初版第1刷発行
2022年 6 月11日　　　第5刷発行

デザイン・イラスト　Season Paper Collection
　　　　　　　　　　ジュリー・コスタズ / メリッサ・ル・ヴァゲレズ

カバー・ブックデザイン　公平恵美
コーディネート・翻訳　トリコロル・パリ（荻野雅代 / 桜井道子）
翻訳　　　　　　　　　パメラミキ
撮影　　　　　　　　　松村大輔（PIE Graphics）
校正　　　　　　　　　広瀬 泉
編集　　　　　　　　　長谷川卓美

発行人　三芳寛要
発行元　株式会社パイ インターナショナル
　　　　〒170-0005　東京都豊島区南大塚 2-32-4
　　　　TEL 03-3944-3981　FAX 03-5395-4830
　　　　sales@pie.co.jp

印刷・製本　図書印刷株式会社

© 2017 Season Paper Collection / PIE International
ISBN978-4-7562-4984-5 C0070
Printed in Japan

参考文献　『「こころ」が伝わる手紙の書き方とマナー文例集』西東社
　　　　　『手紙・はがき・一筆箋の書き方と文例集』主婦の友社

PARIS - 100 Writing & Crafting Papers :
Season Paper Collection

Designs & Illustrations : Season Paper Collection
　　　　　　　　　　Julie Costaz / Mélissa Le Vaguerèse

Cover & book design : Emi Kohei
Coordination & French translation :
Tricolor Paris (Masayo Ogino / Michiko Sakurai)
English translation : Pamela Miki
Photography : Daisuke Matsumura (PIE Graphics)
Proofreading : Izumi Hirose
Editing : Takumi Hasegawa

Published by : Hiromoto MIyoshi

PIE International Inc.
2-32-4 Minami-Otsuka, Toshima-ku,
Tokyo 170-0005 JAPAN
sales@pie.co.jp

Season Paper Collection
シーズン・ペーパー・コレクション
www.seasonpapercollection.com

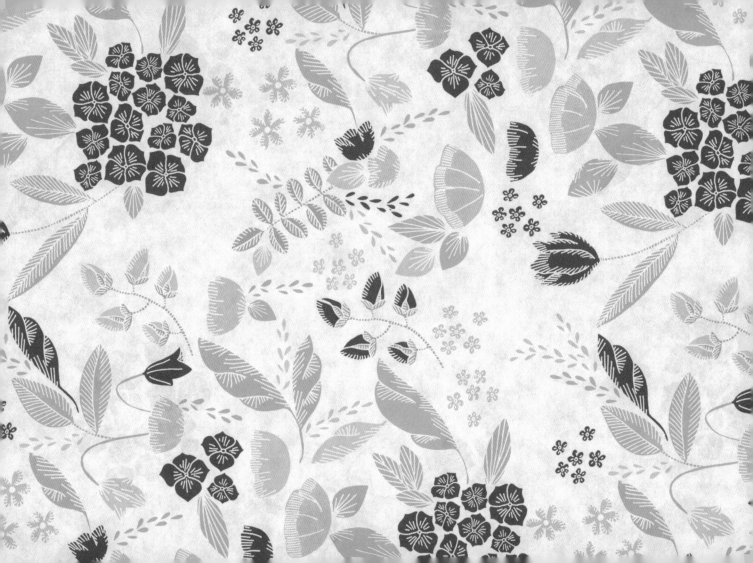

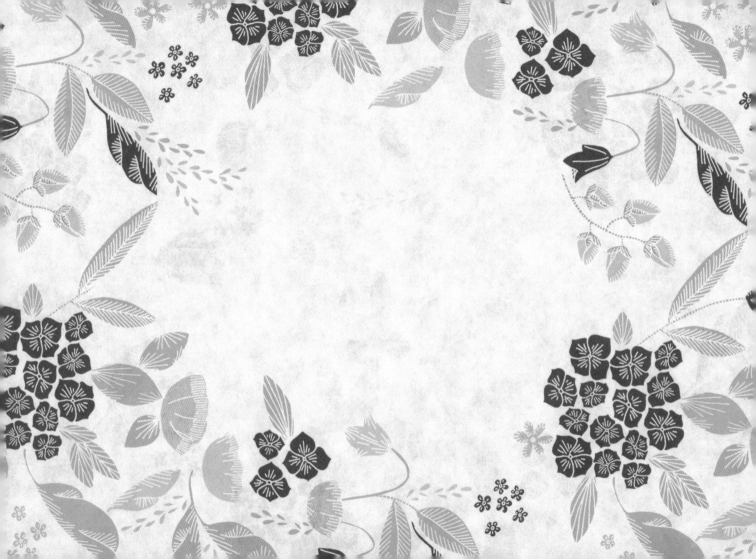

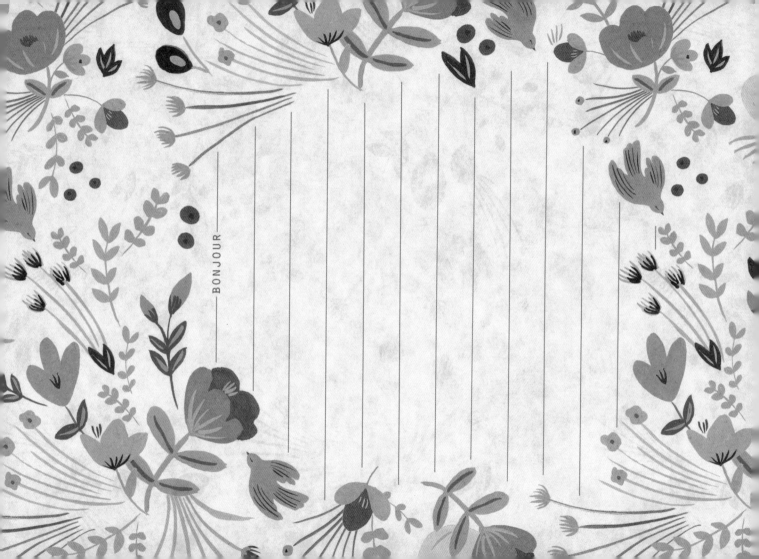

BONJOUR

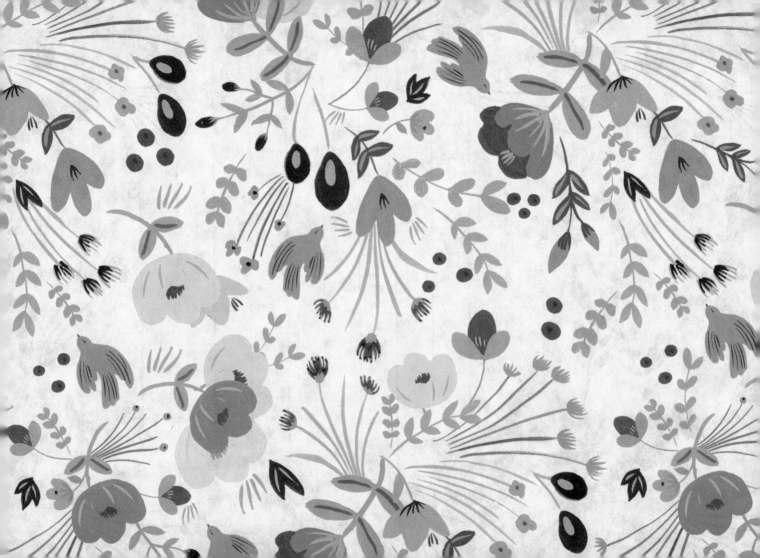

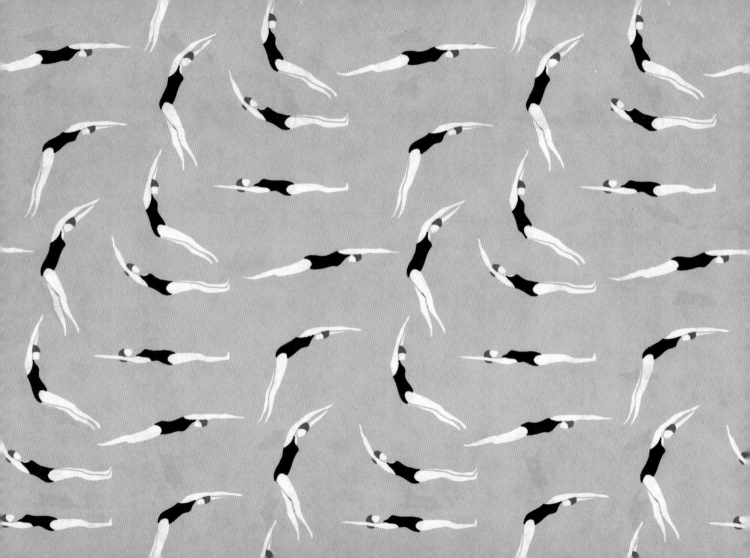

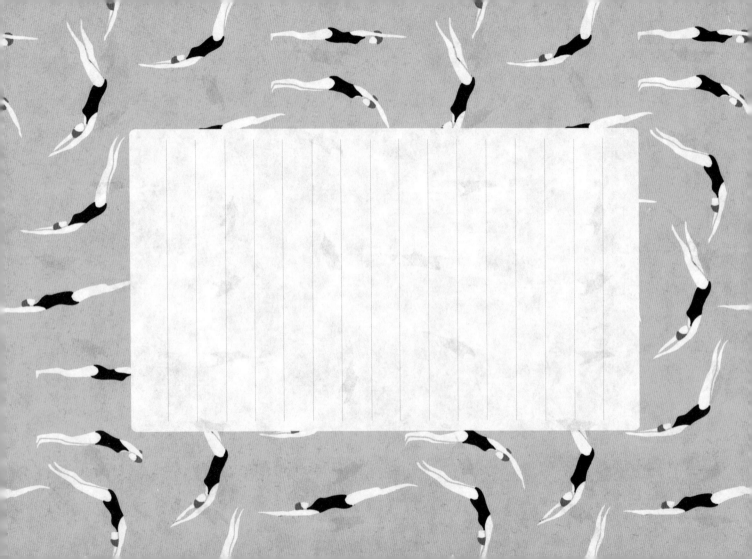

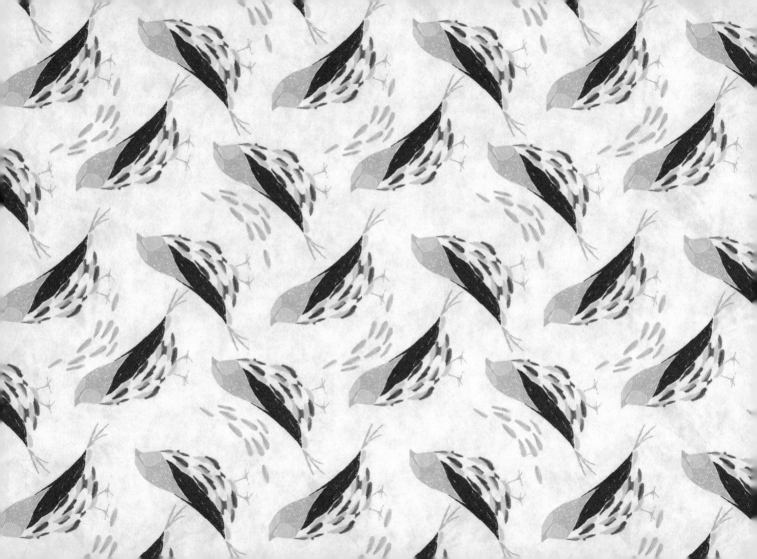

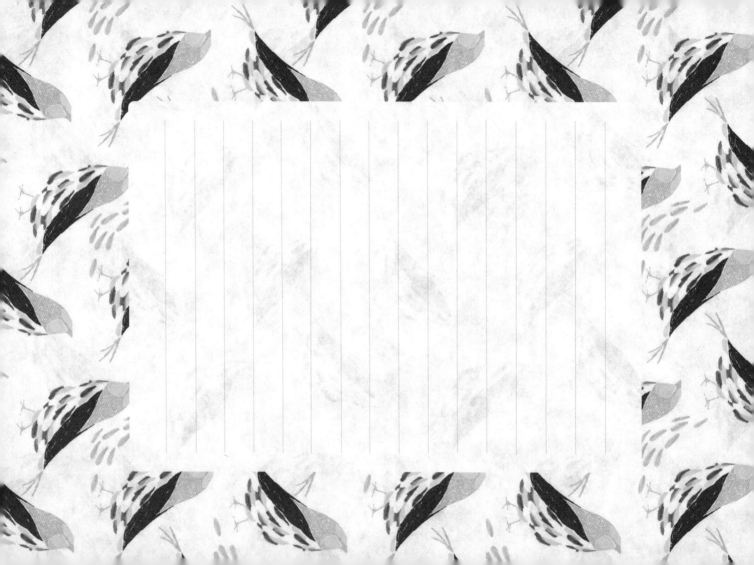

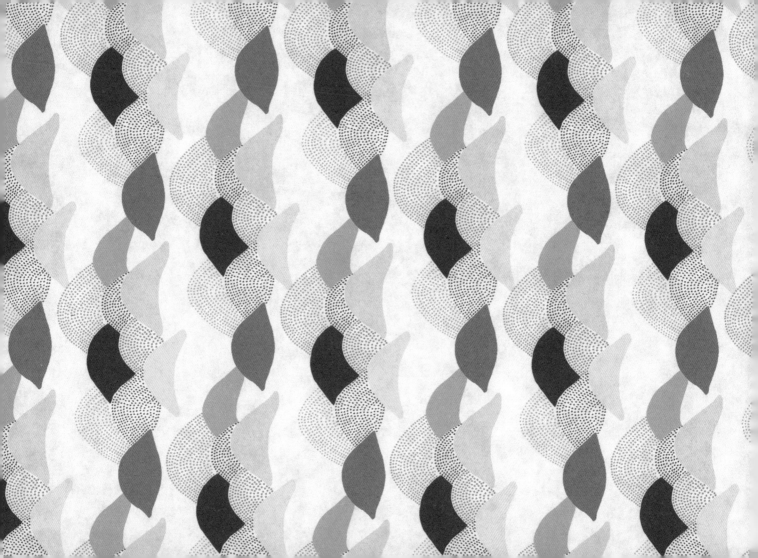

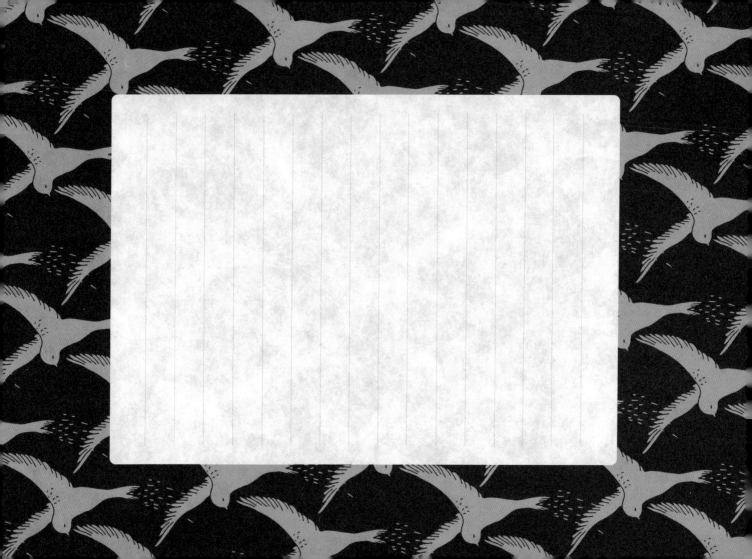

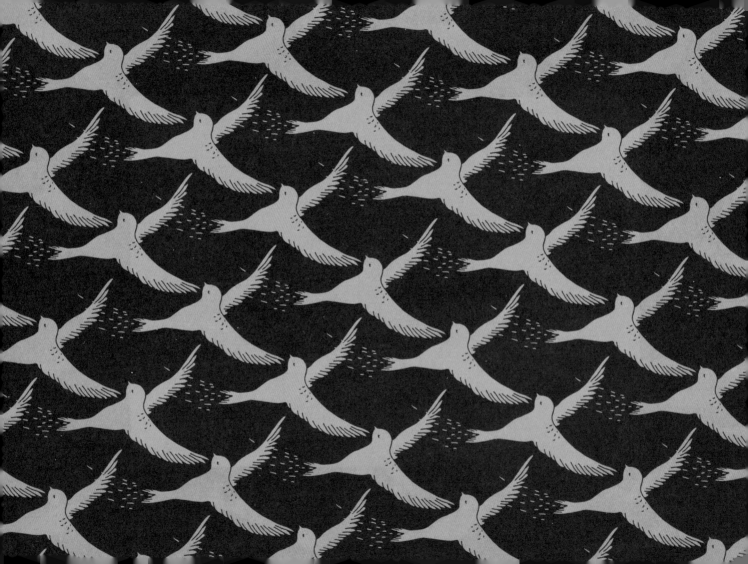

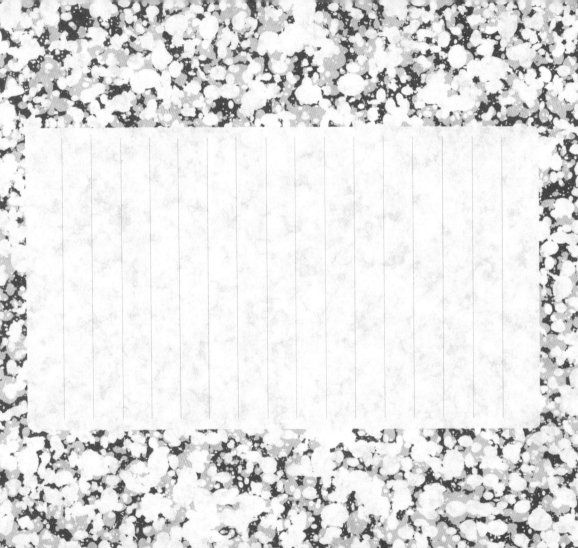

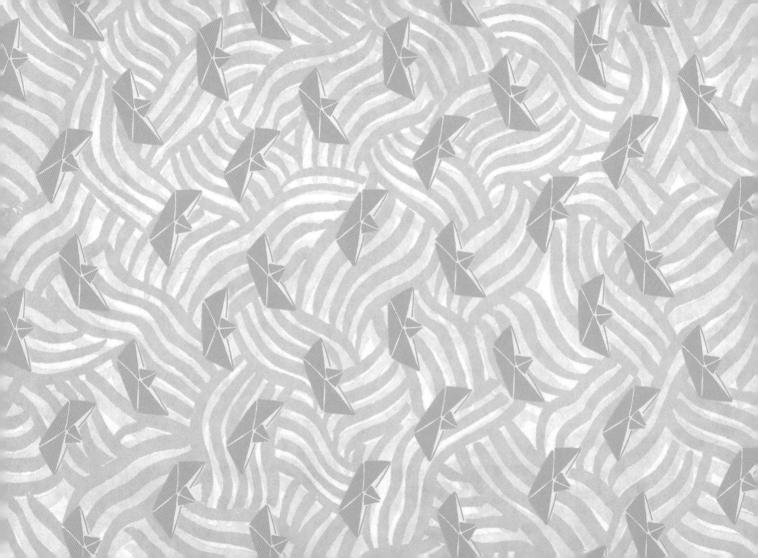

BONJOUR

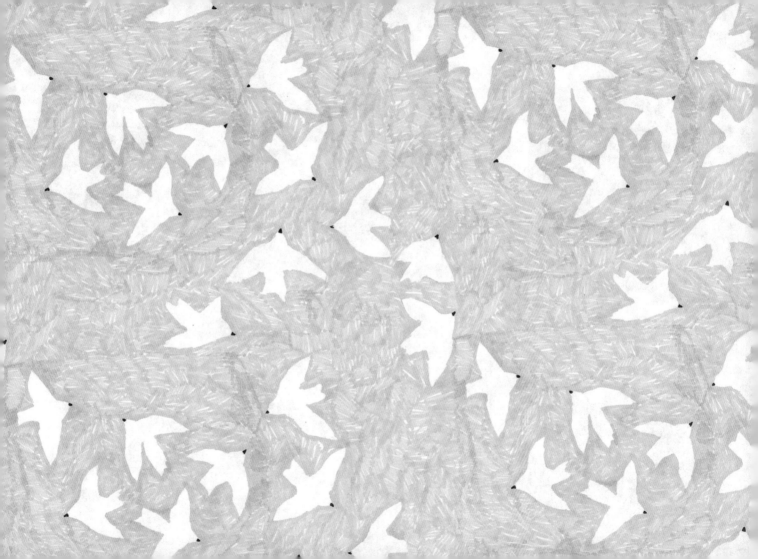

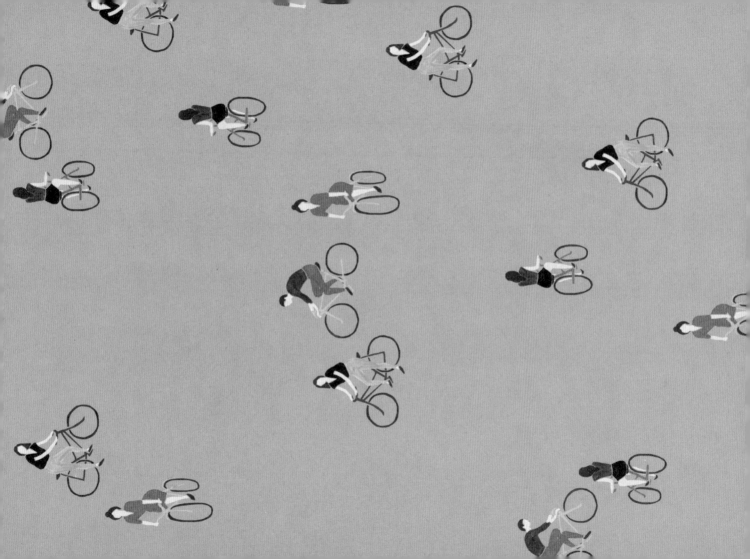

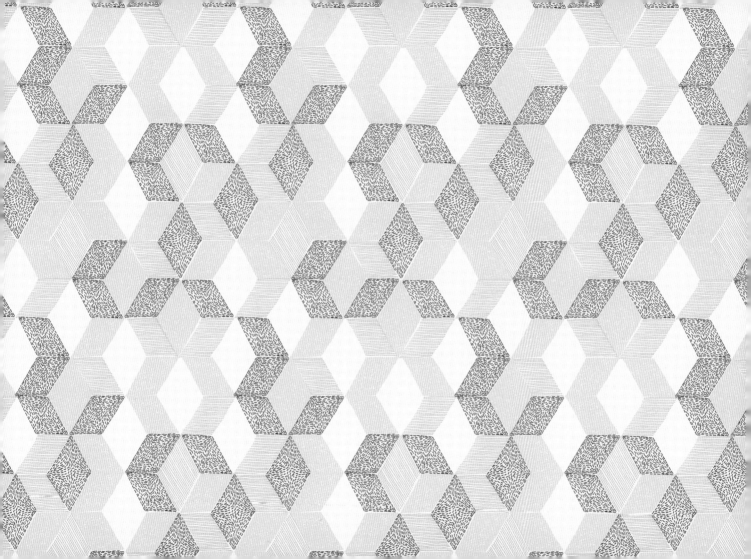

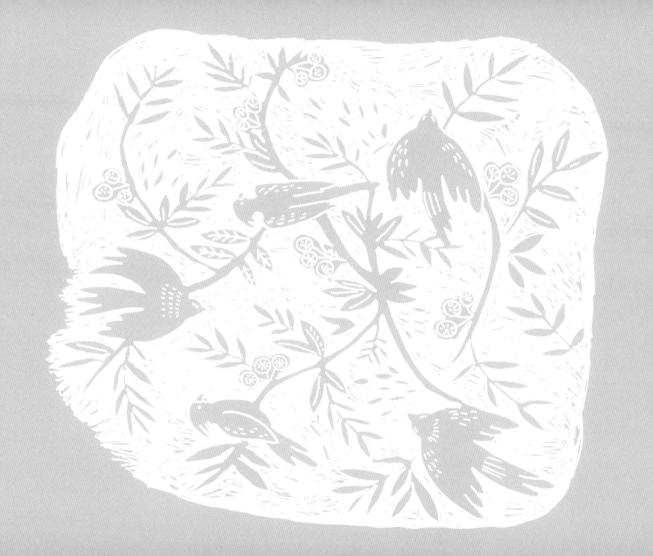

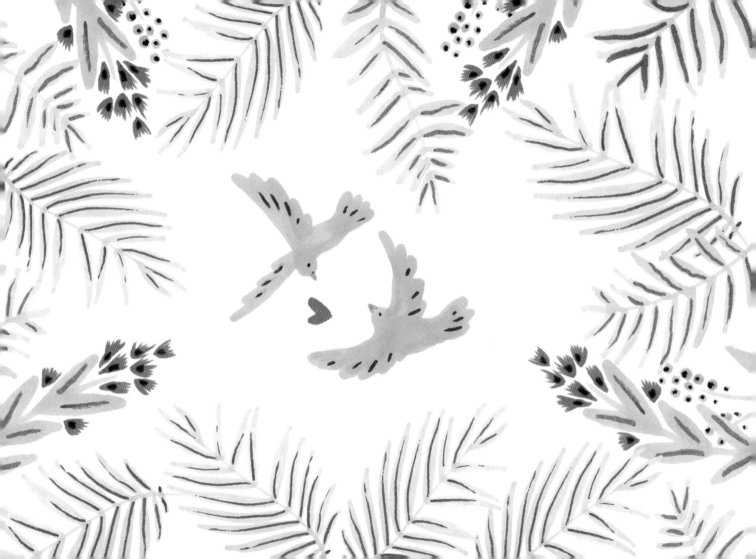

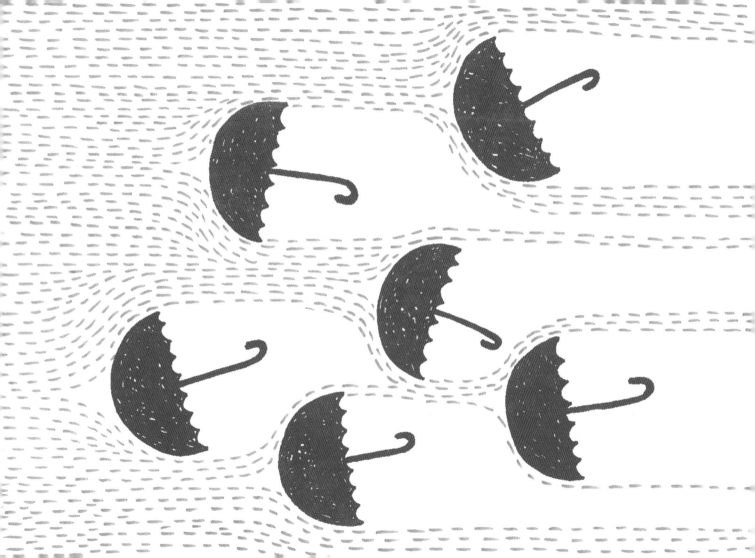

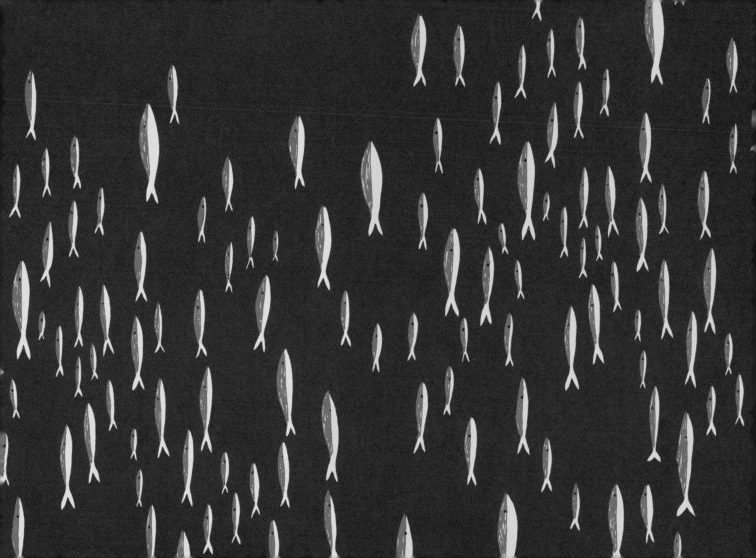

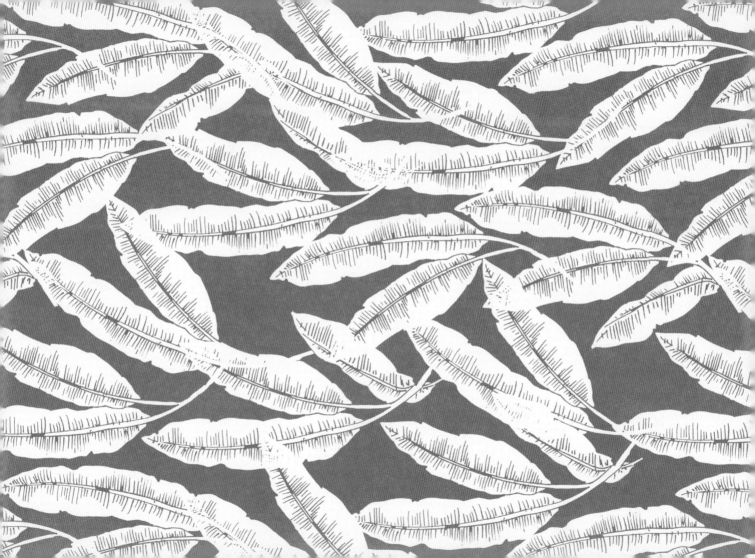

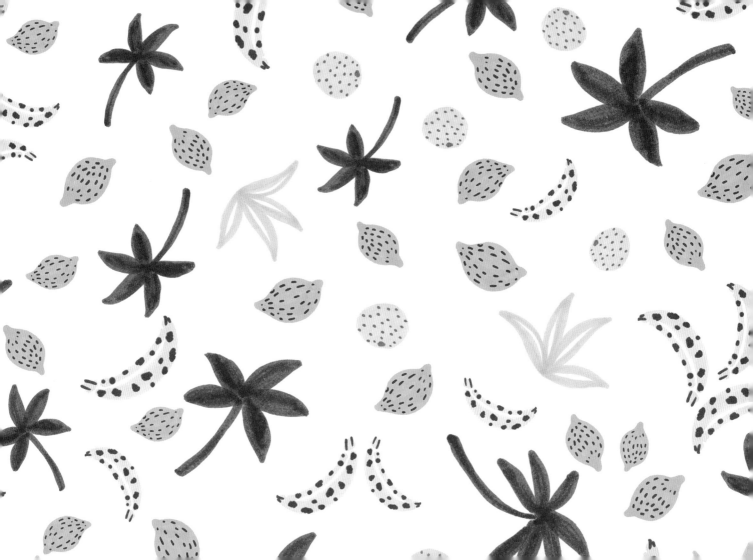

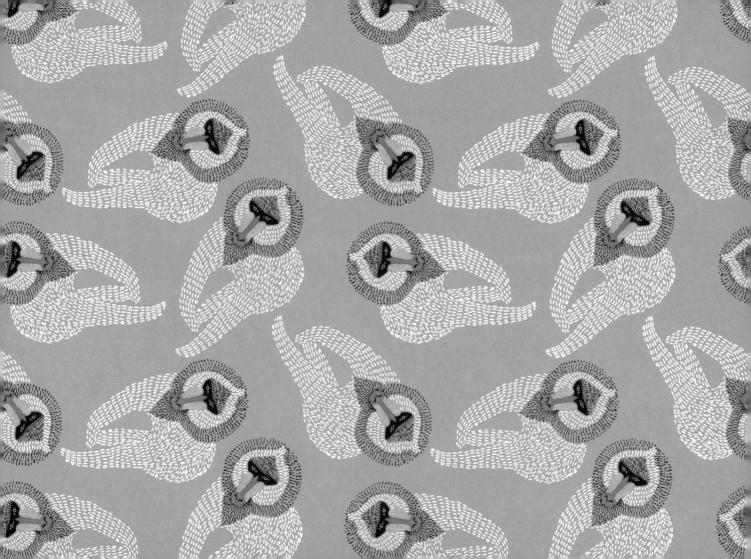

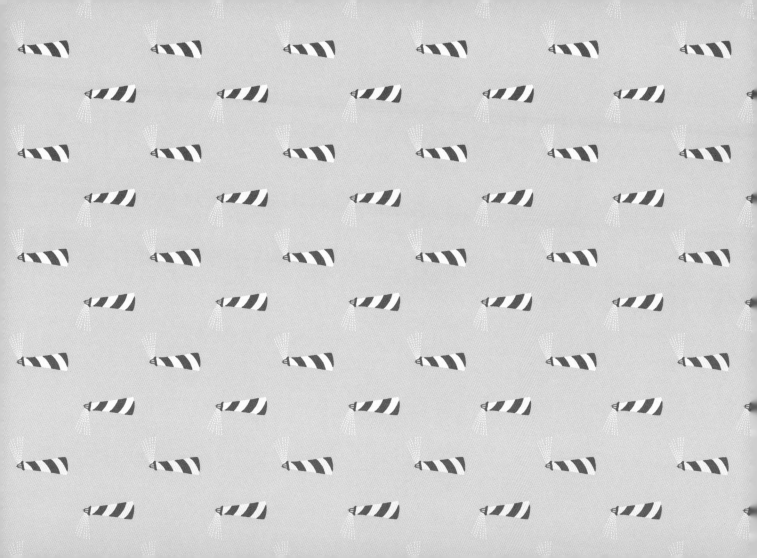

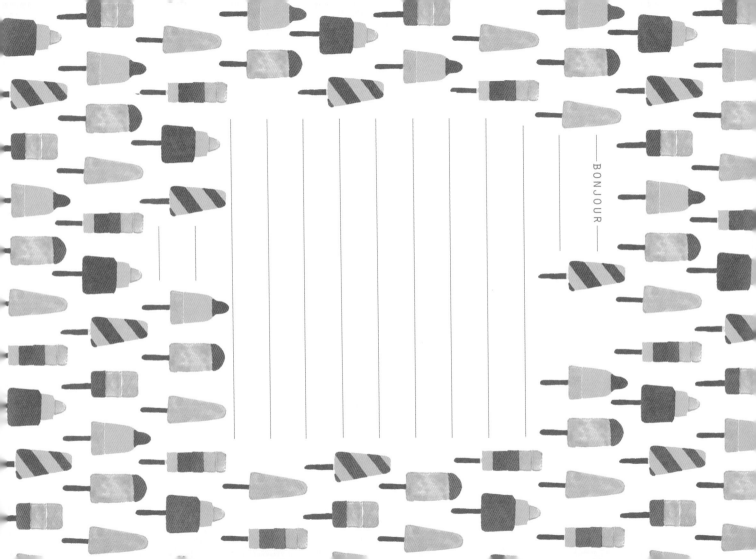

BONJOUR

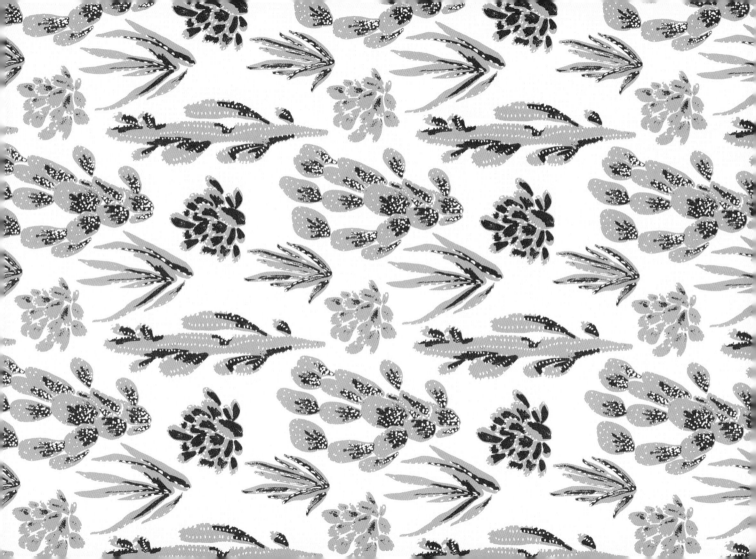

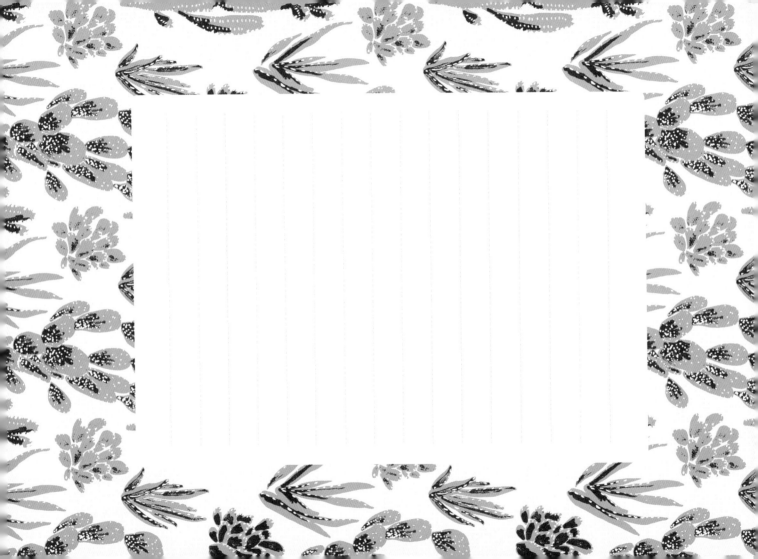

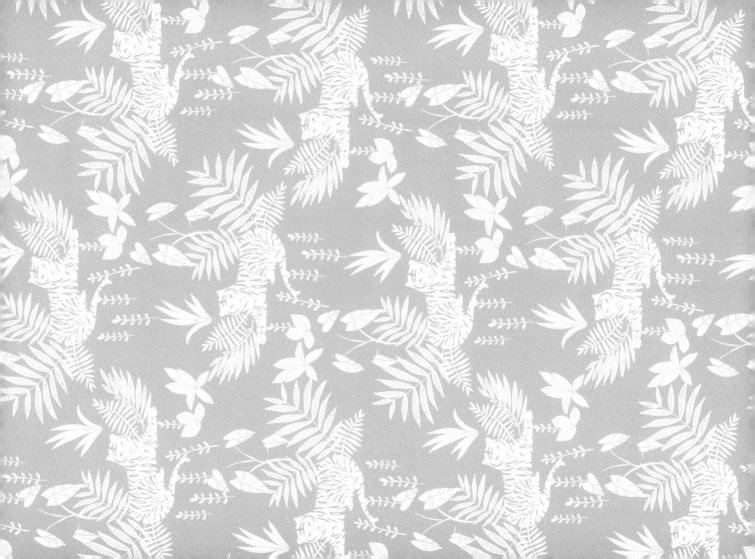

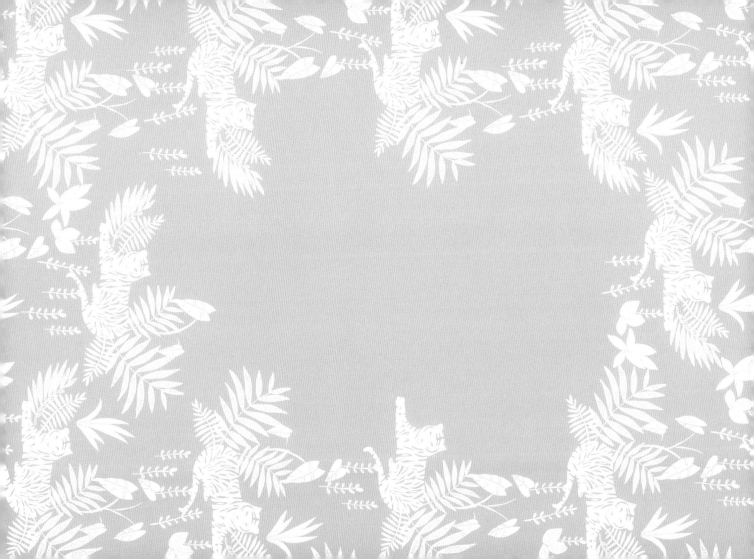

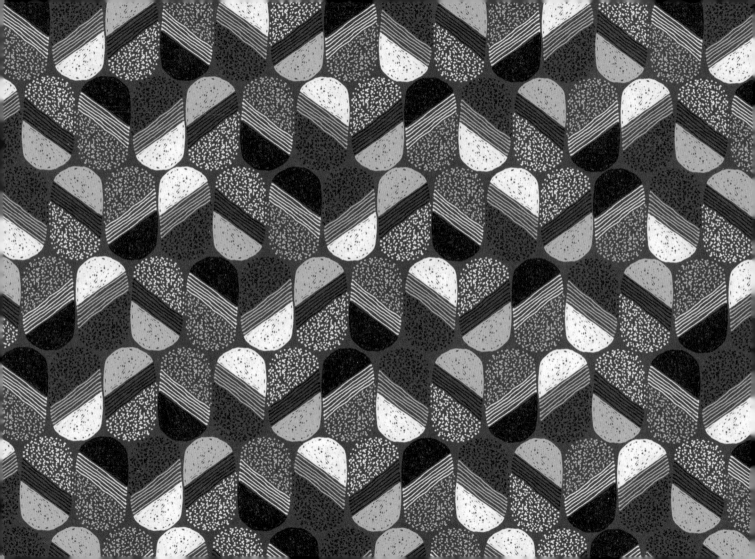

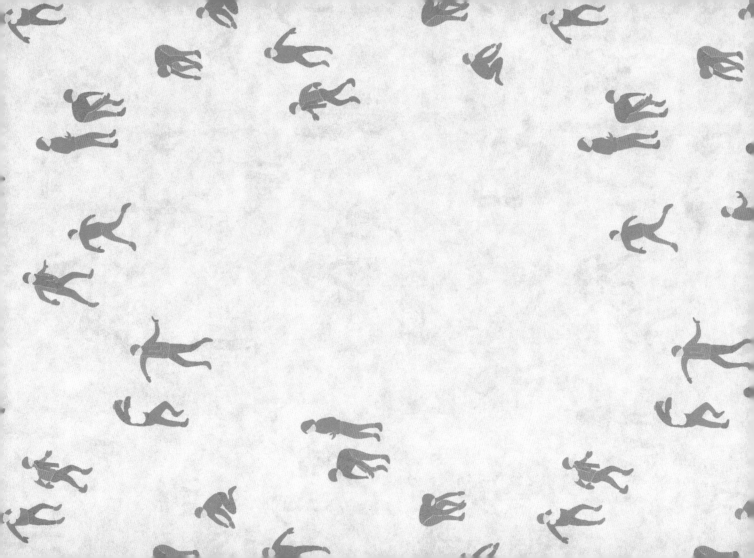

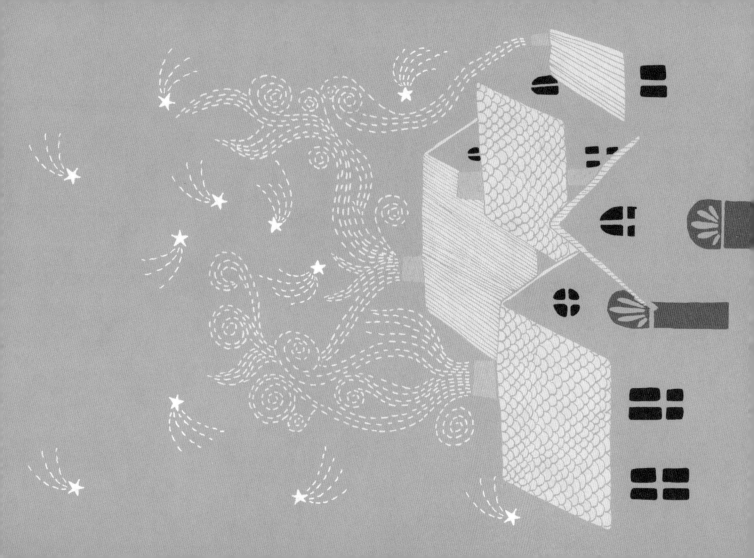

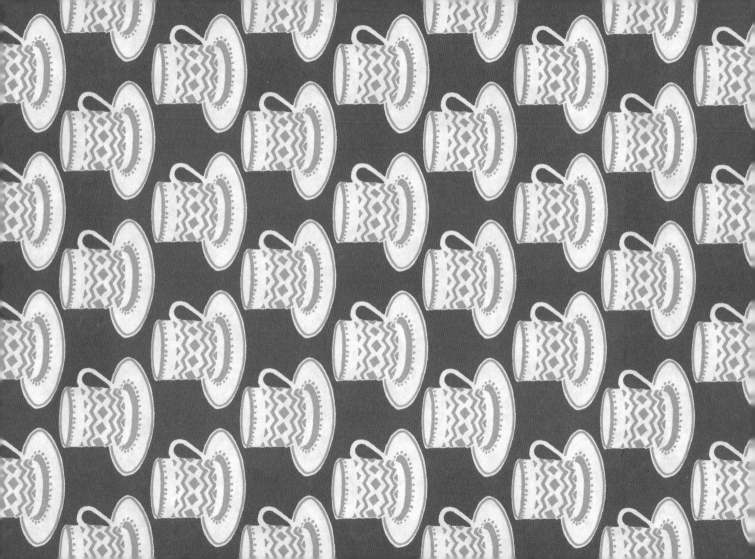

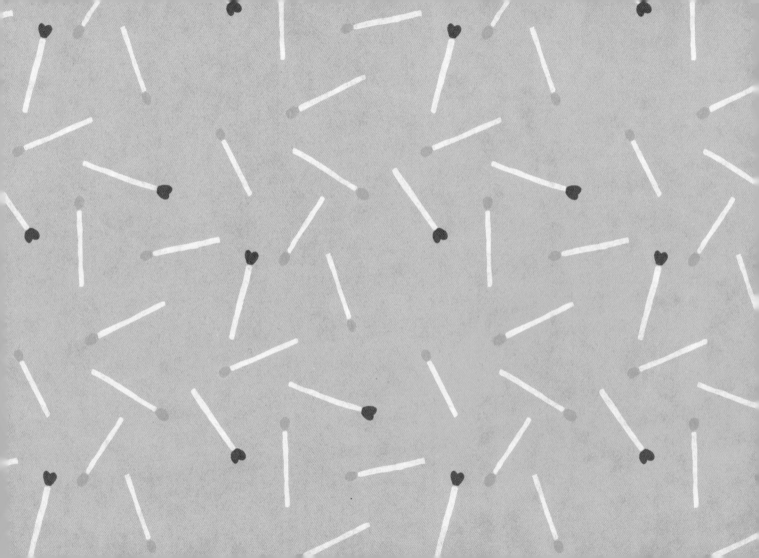

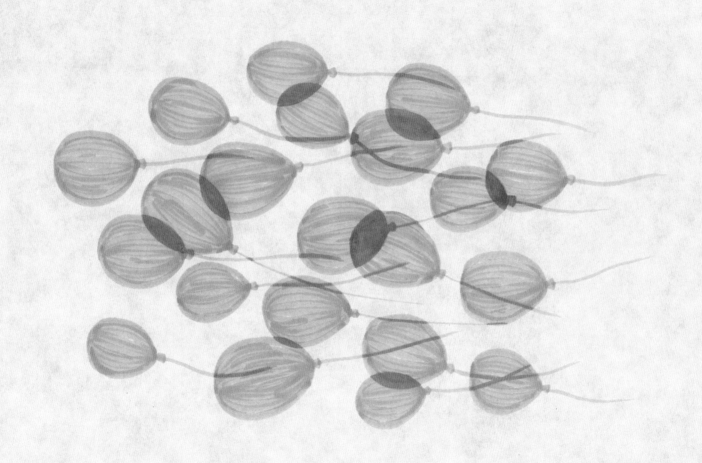

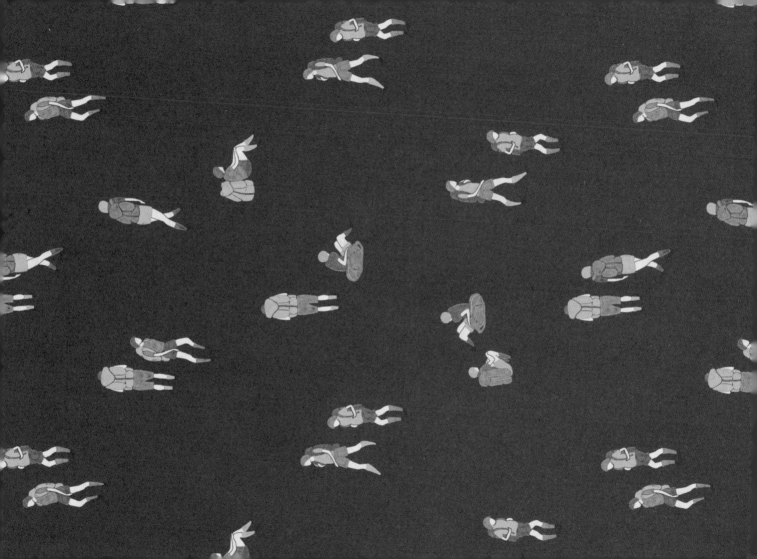

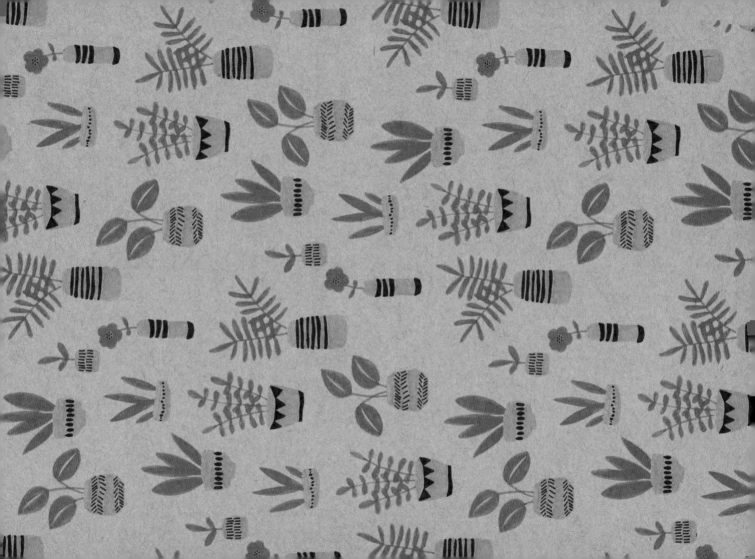

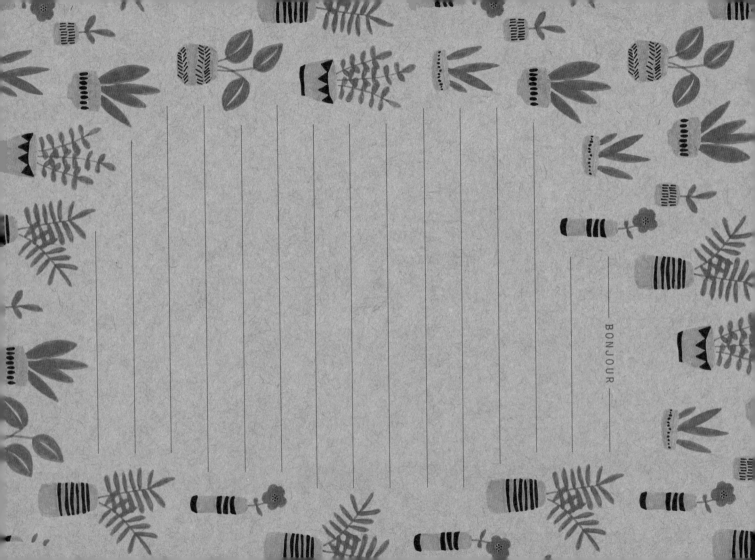

BONJOUR

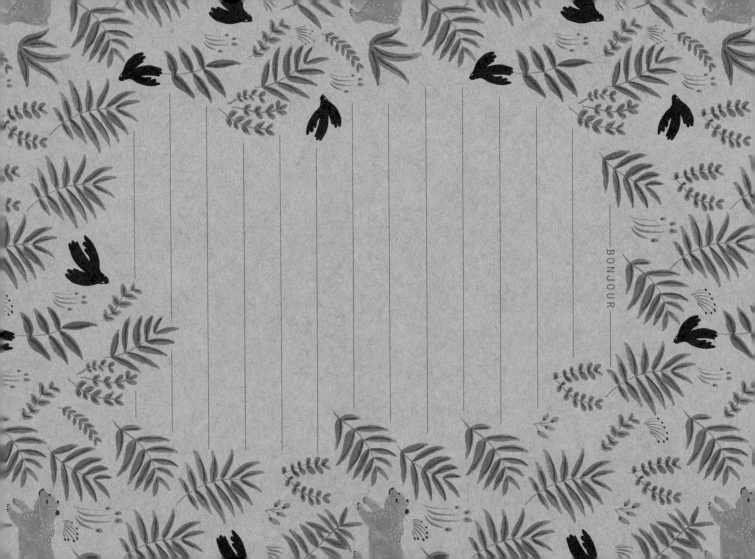

BONJOUR

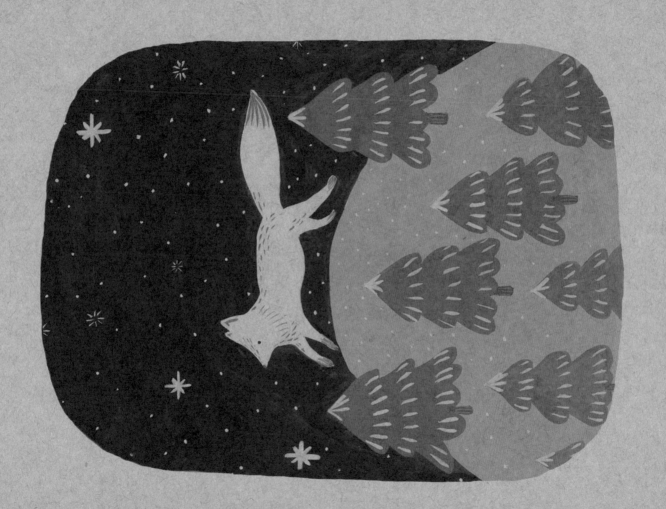

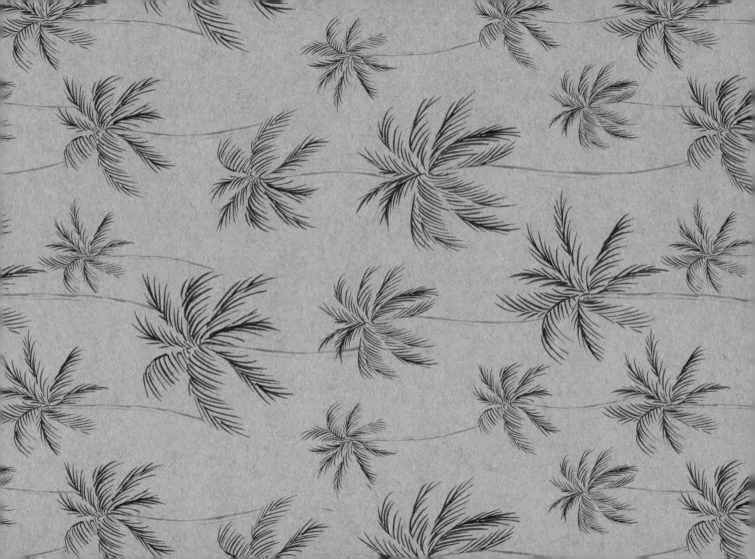

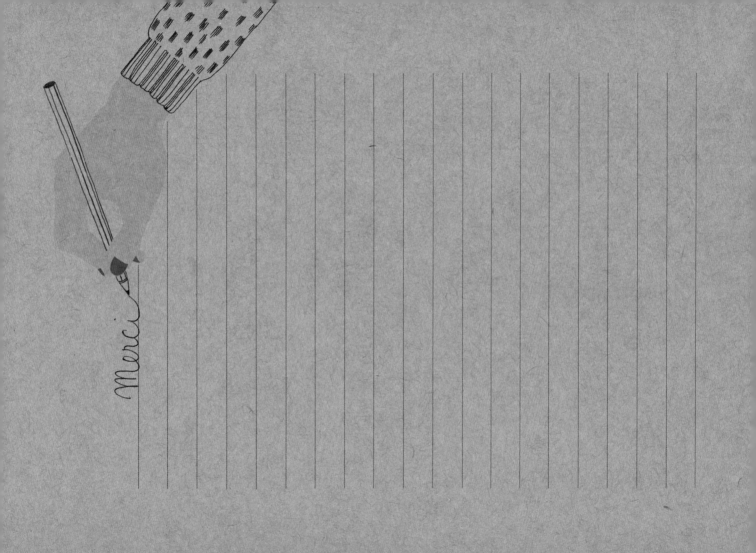

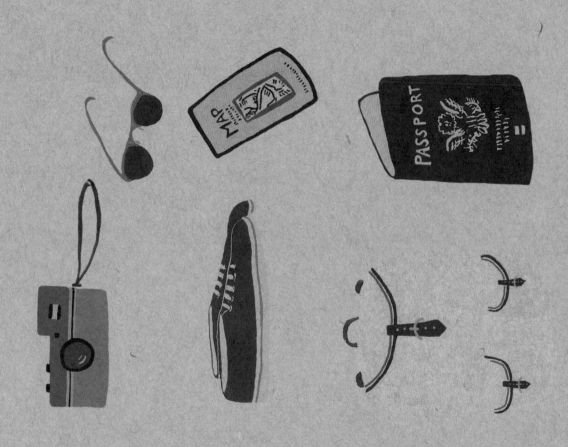

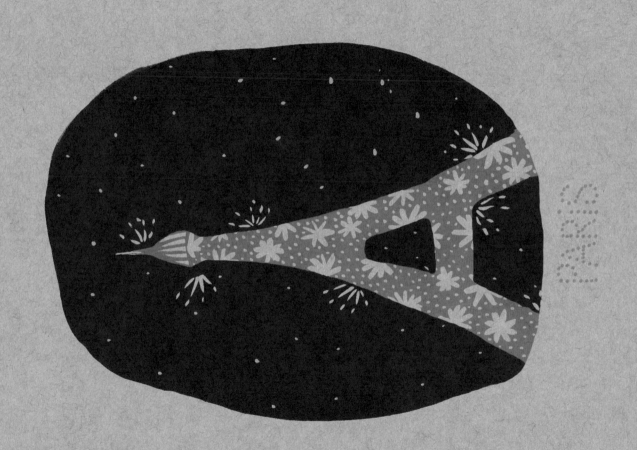

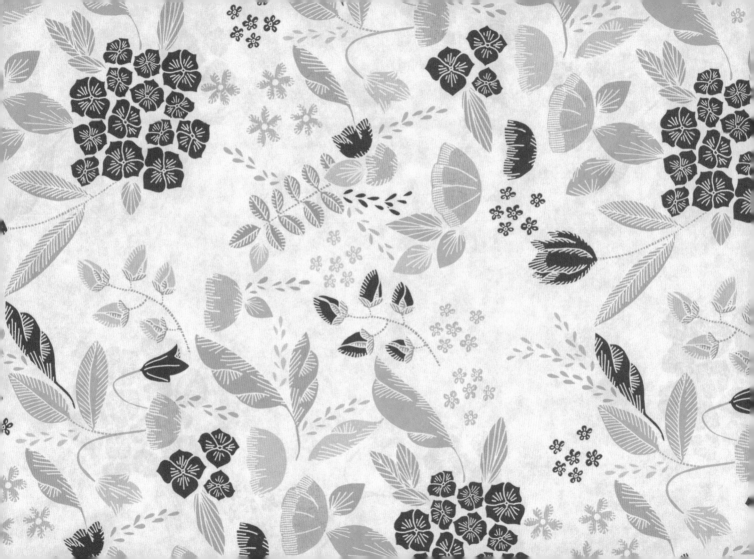

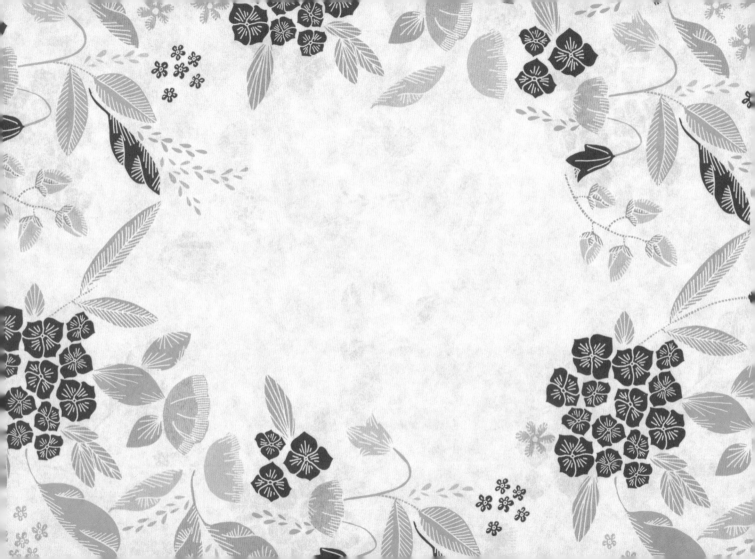

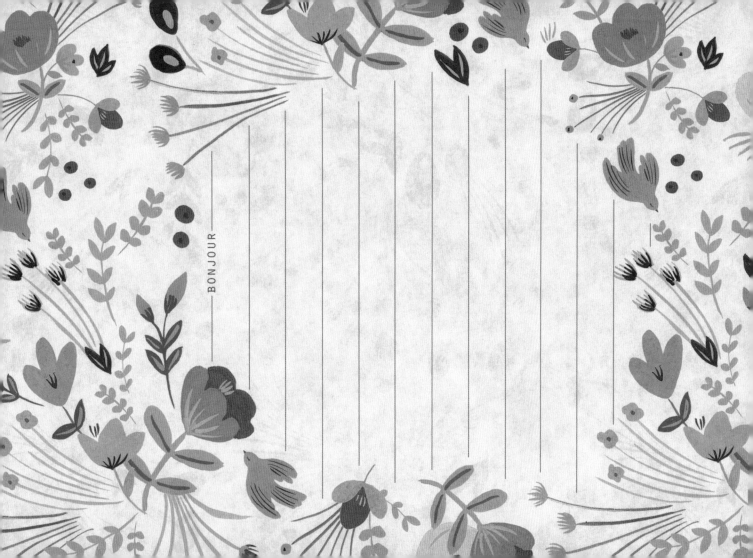

BONJOUR

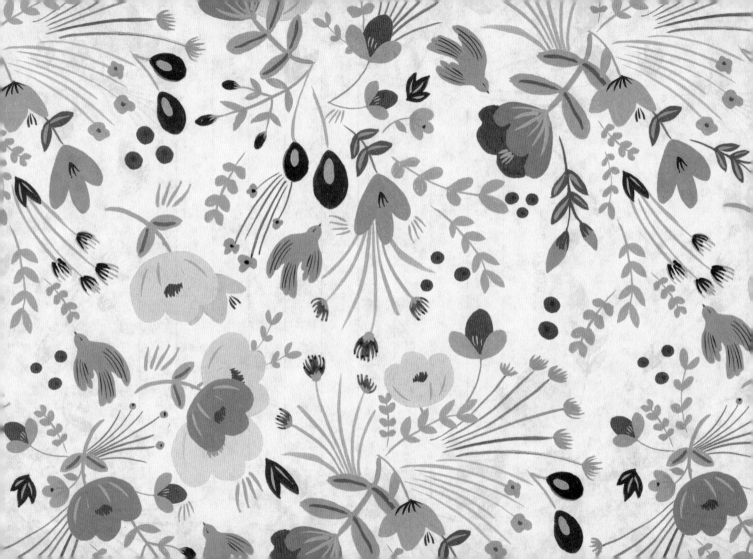

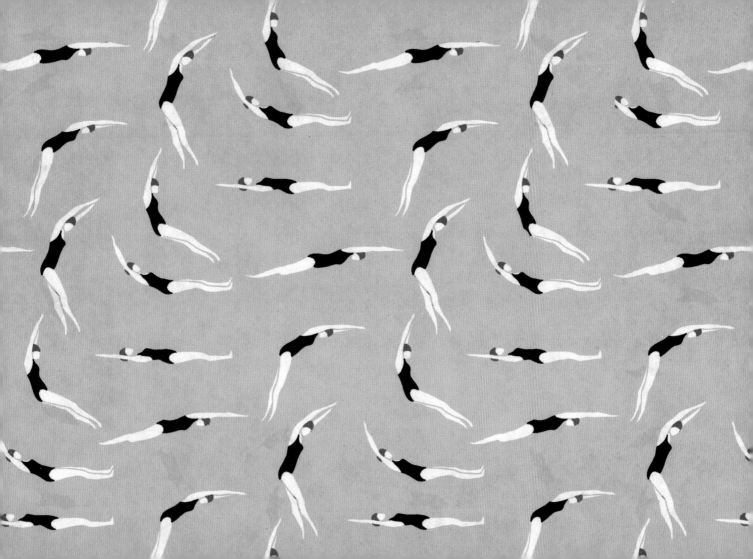

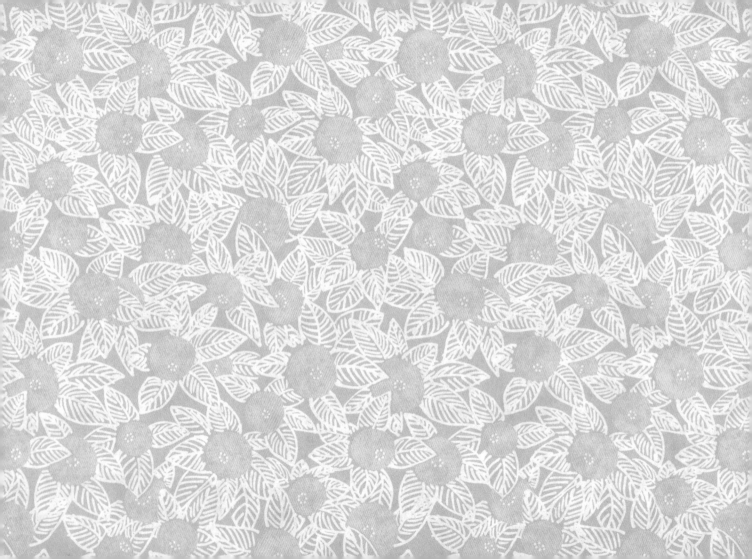

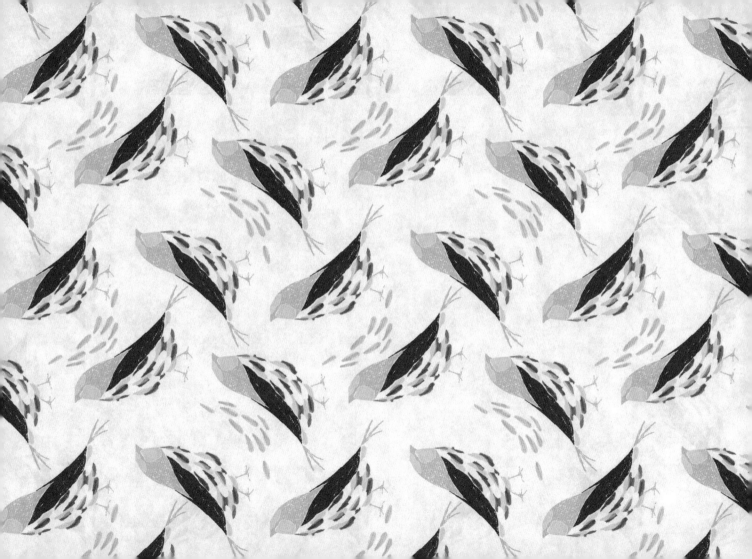

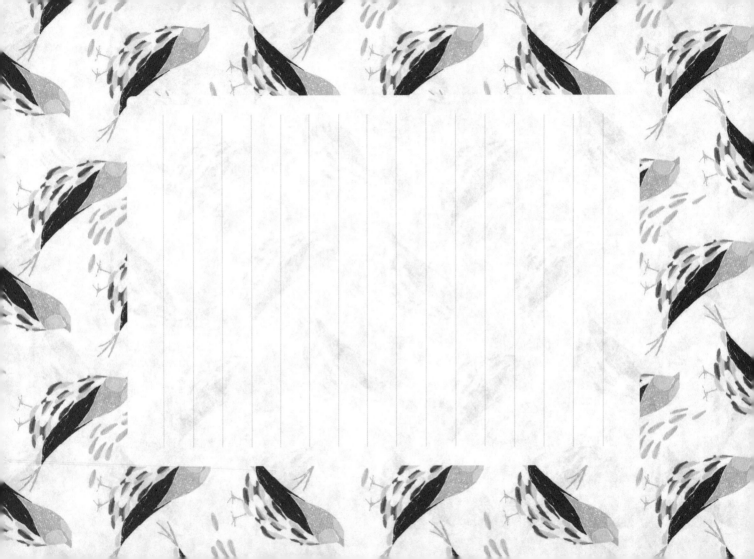

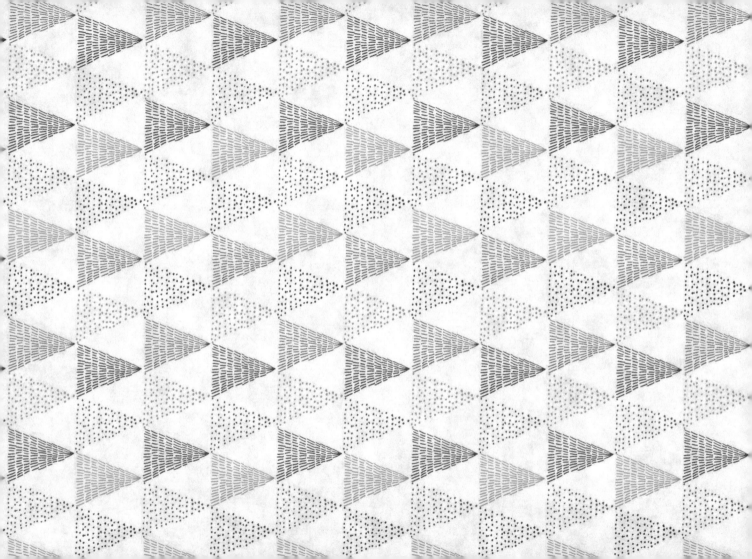

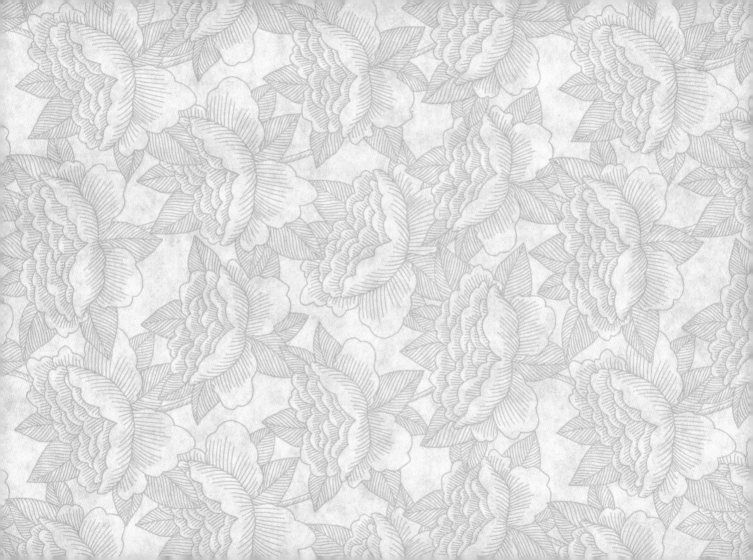

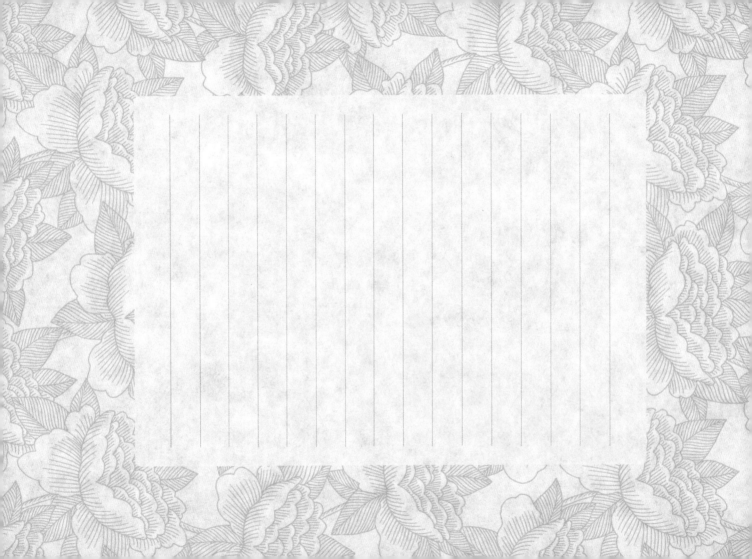

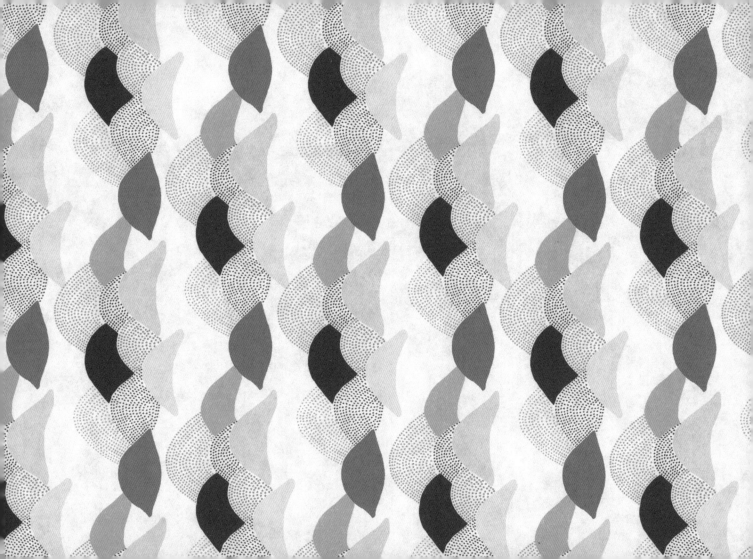

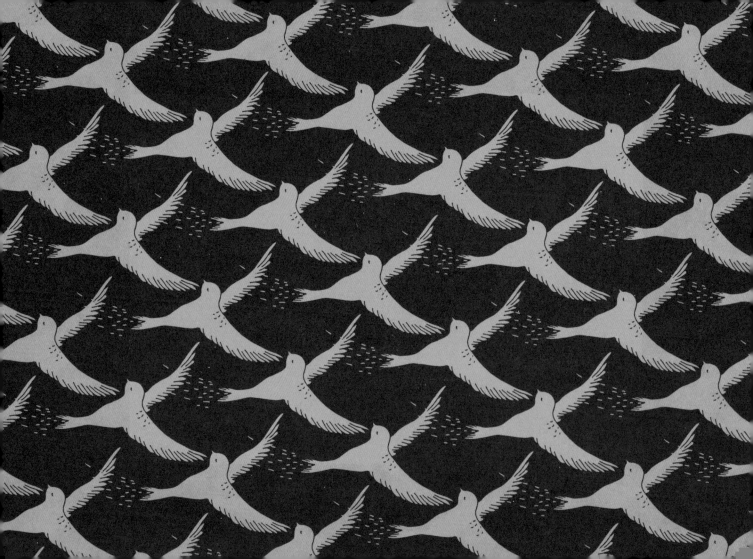

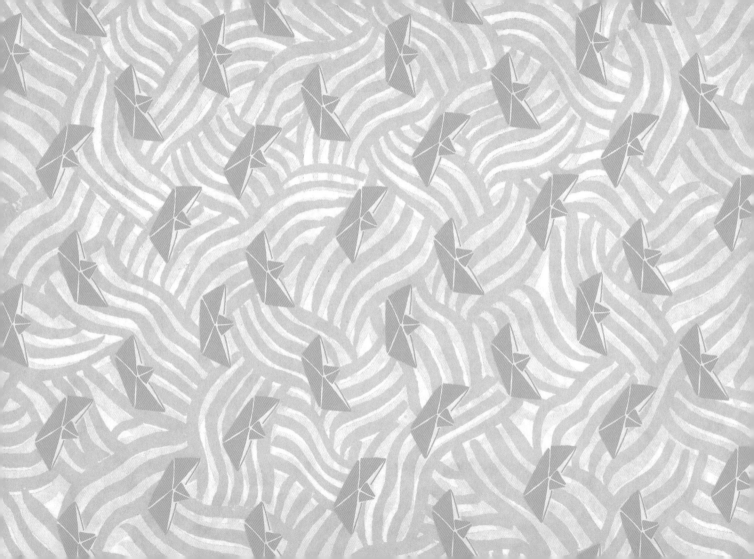

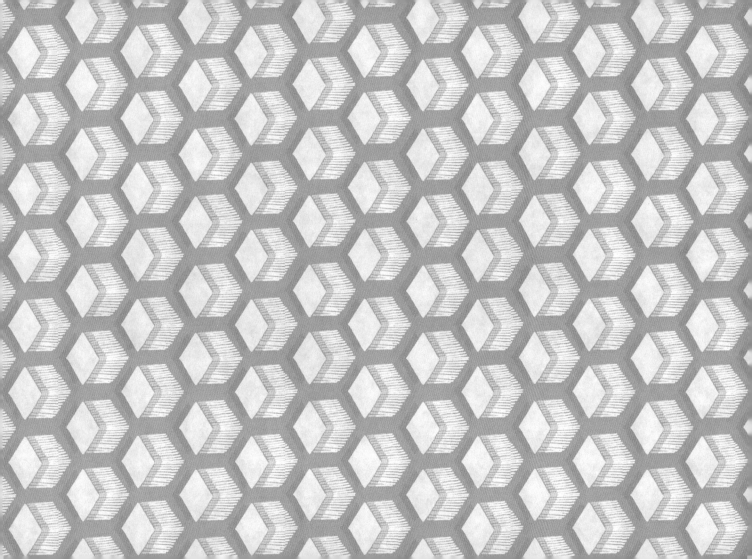

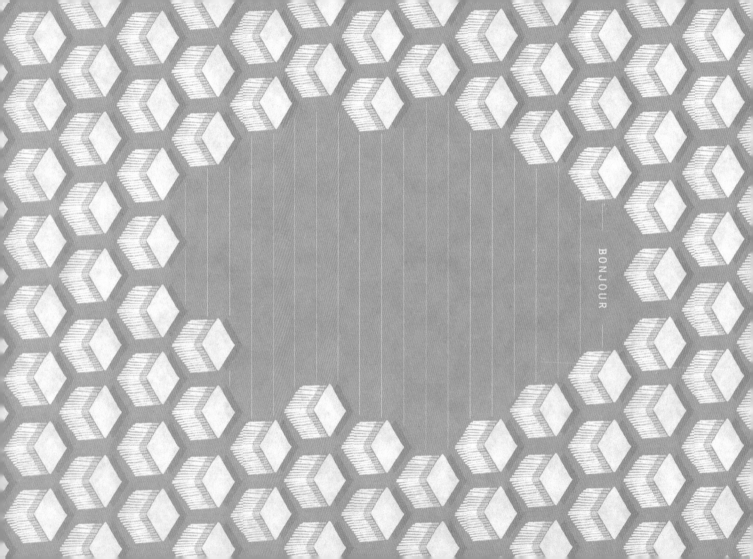

BONJOUR

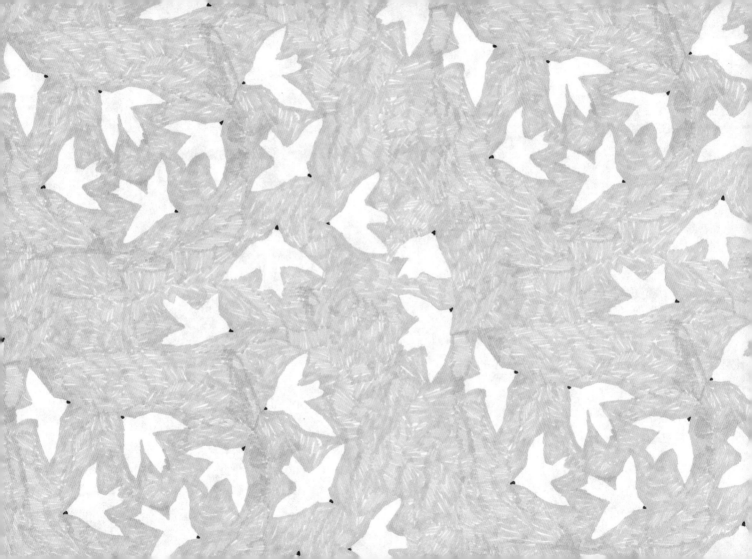

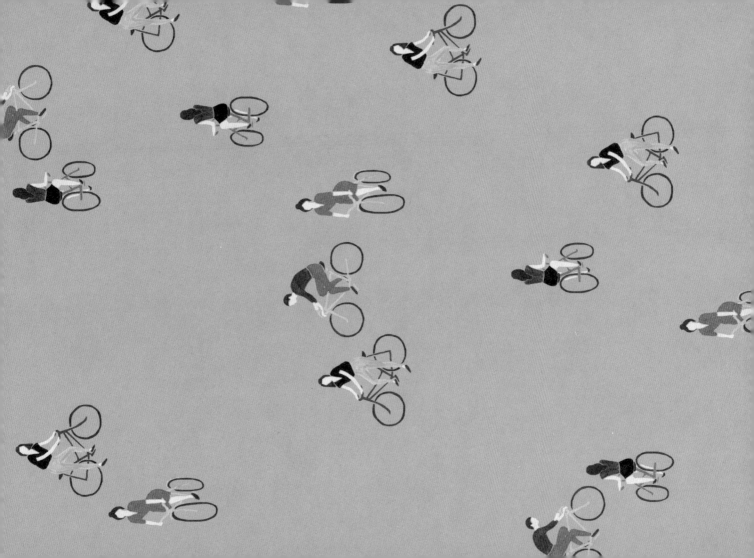

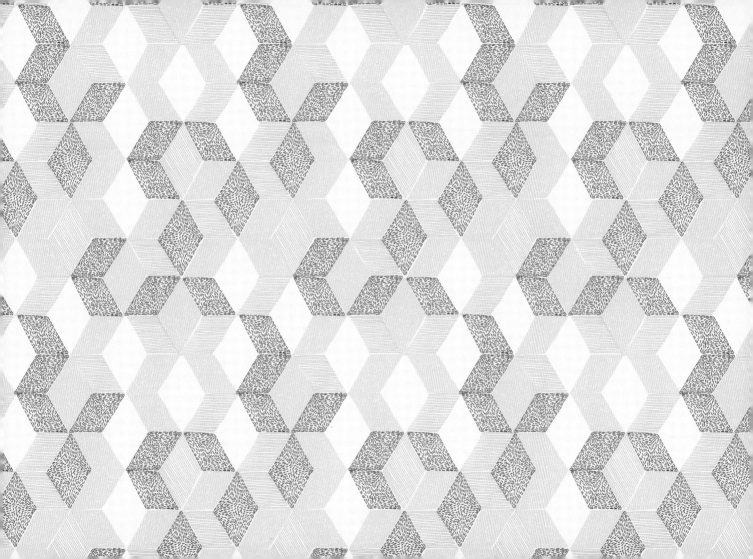

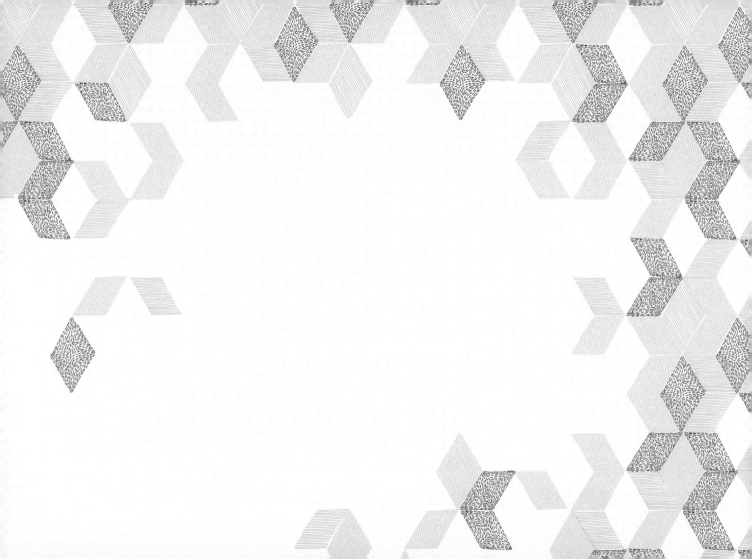

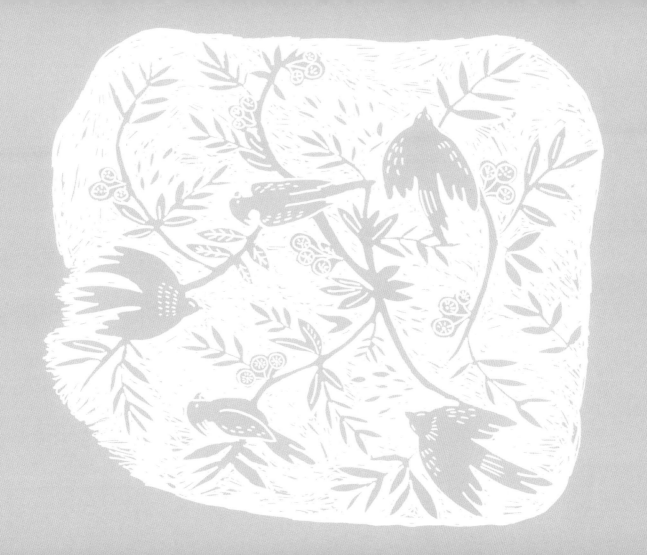

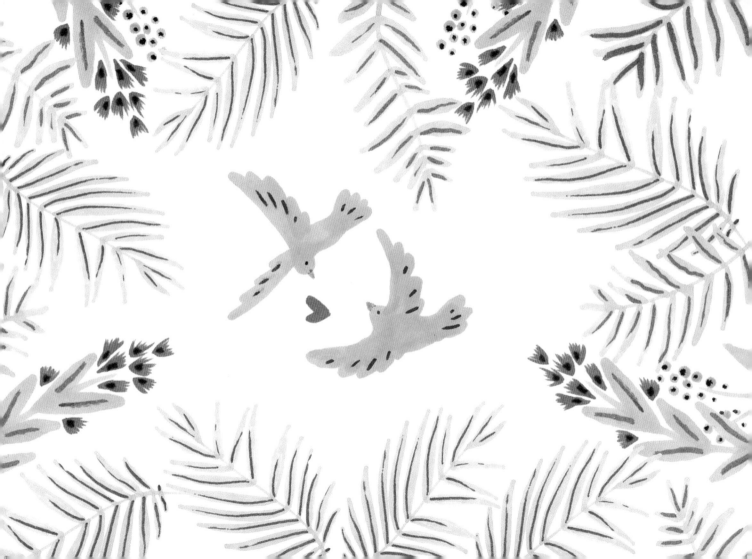

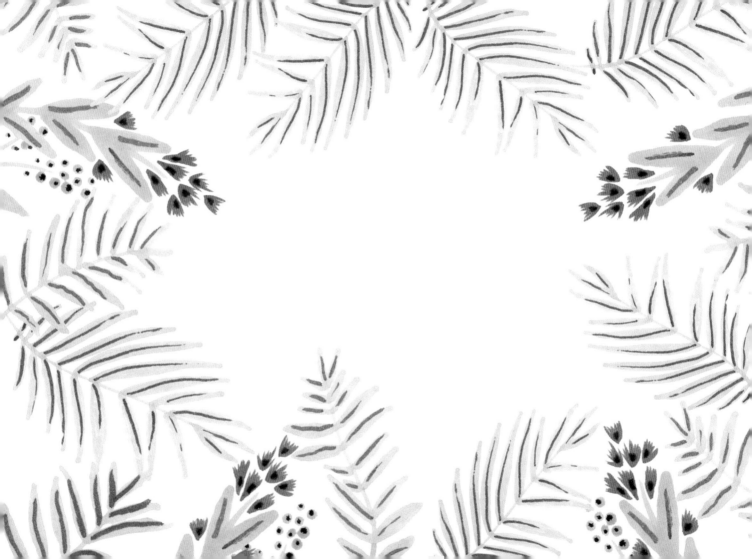

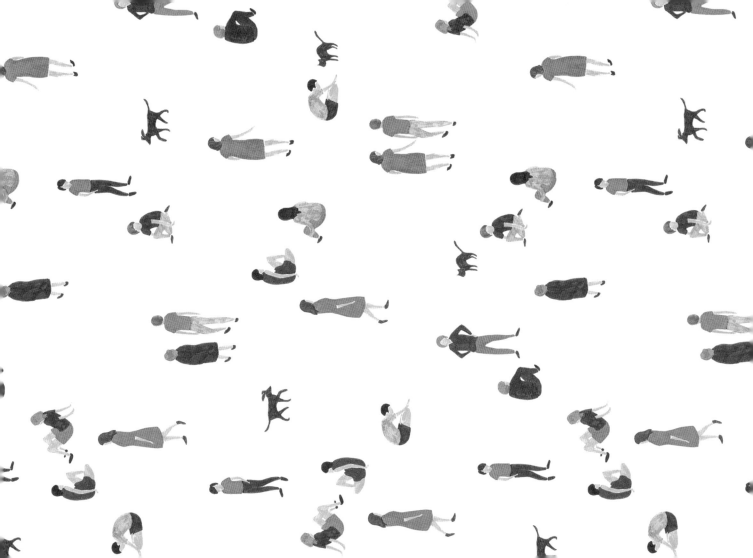

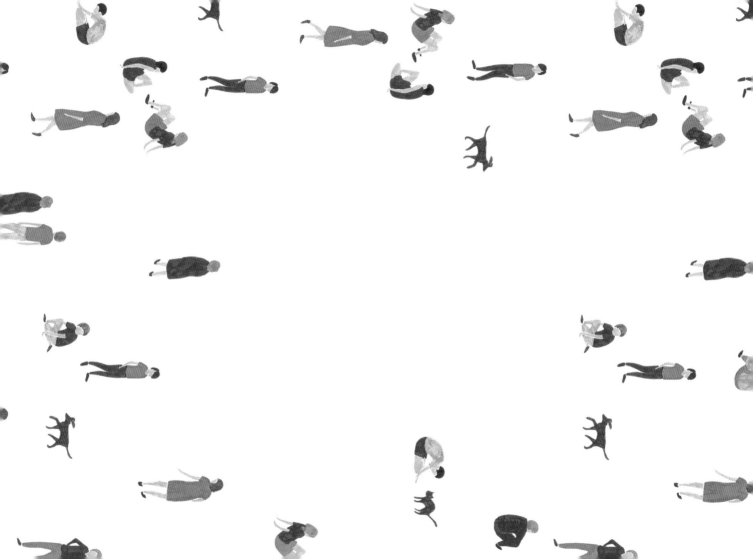

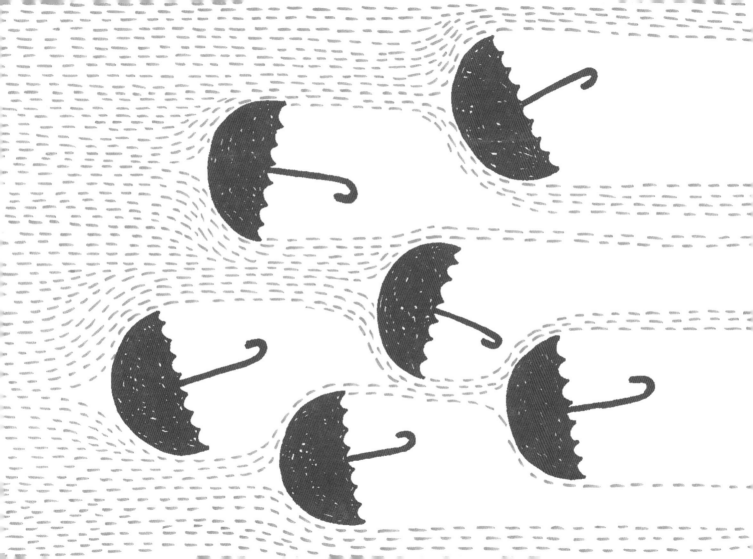

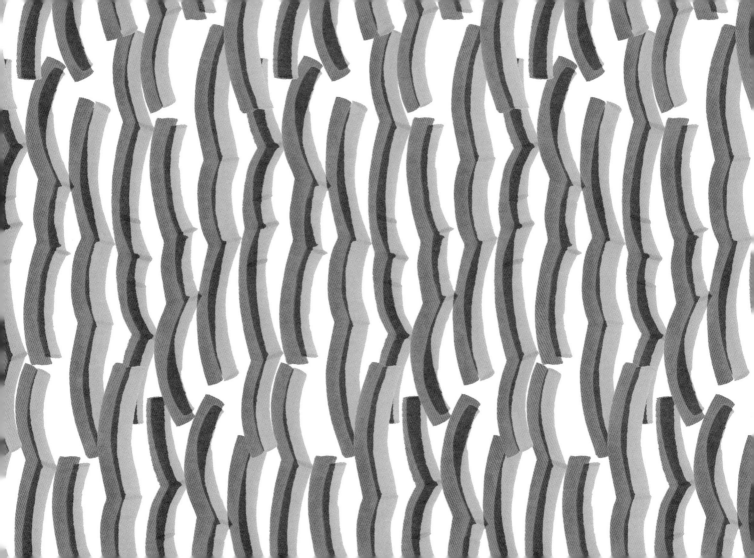

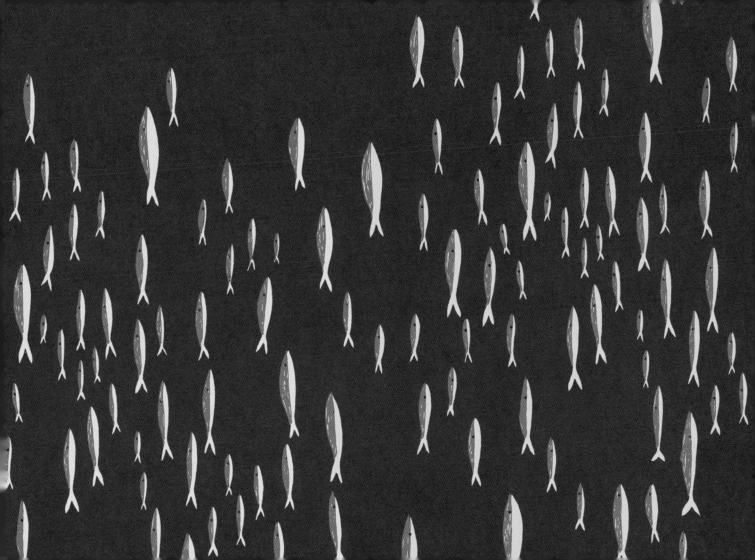

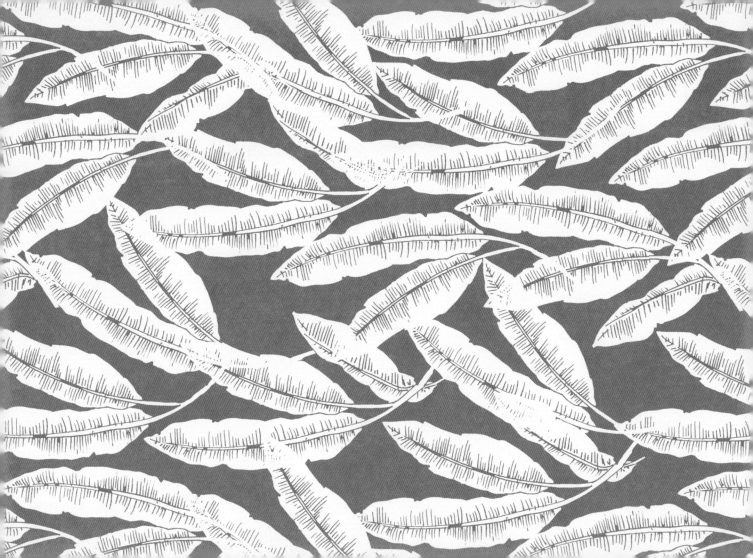

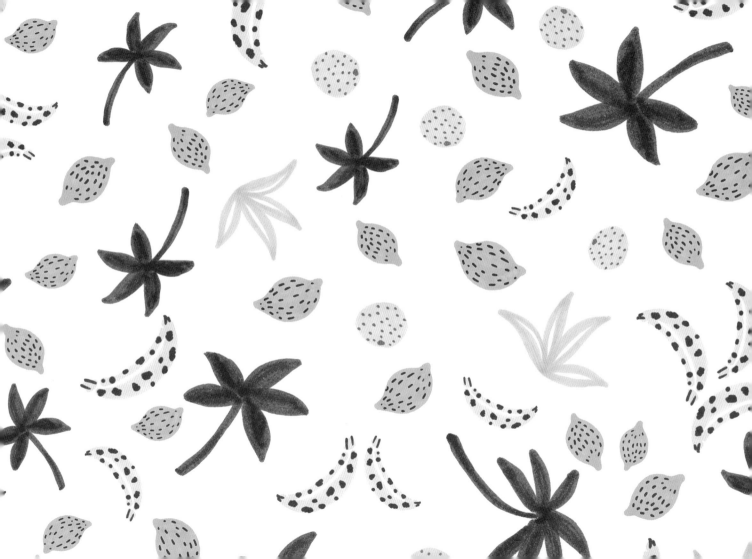

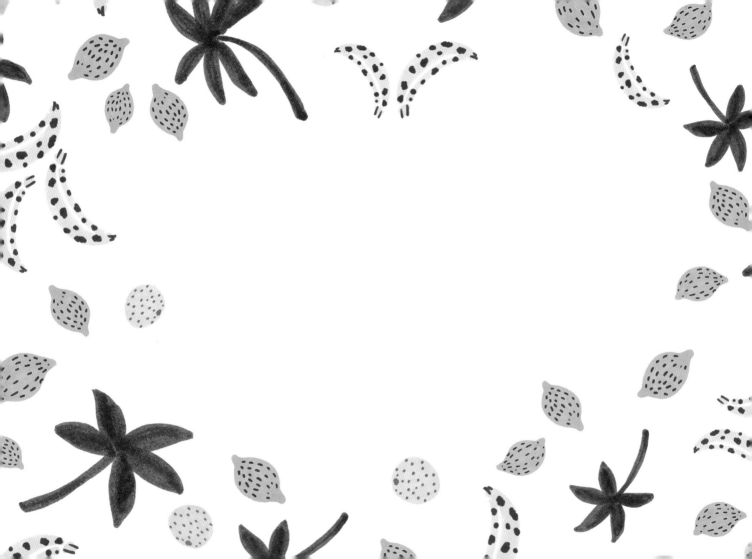

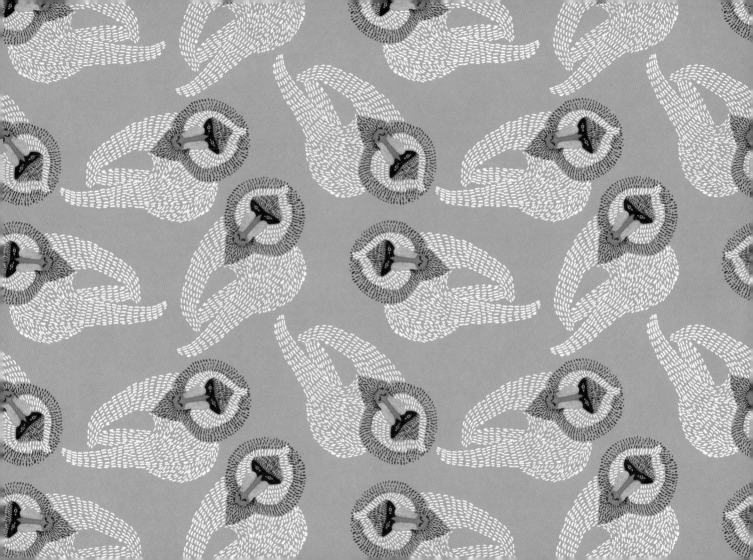

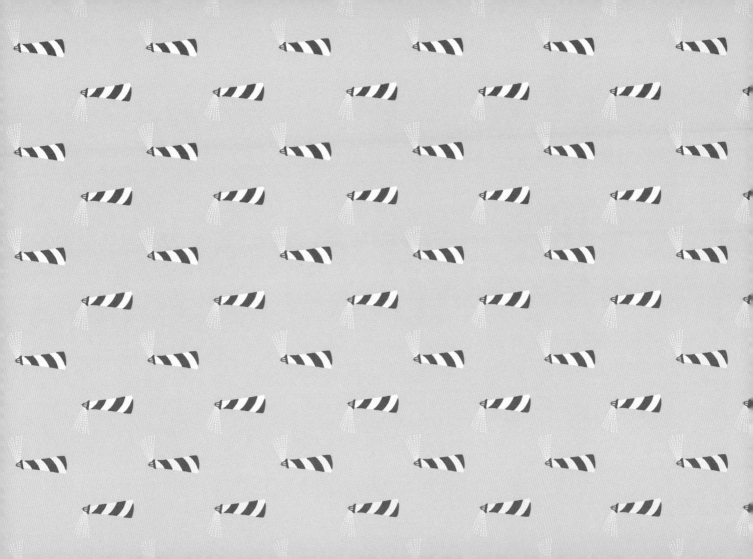

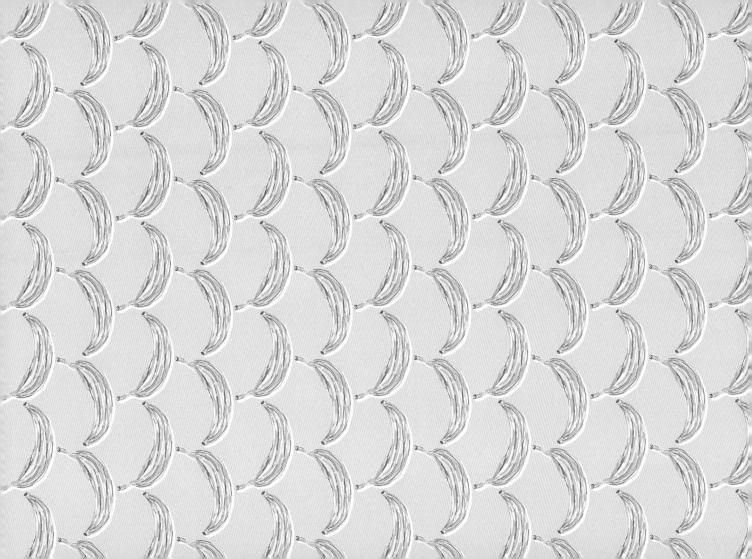

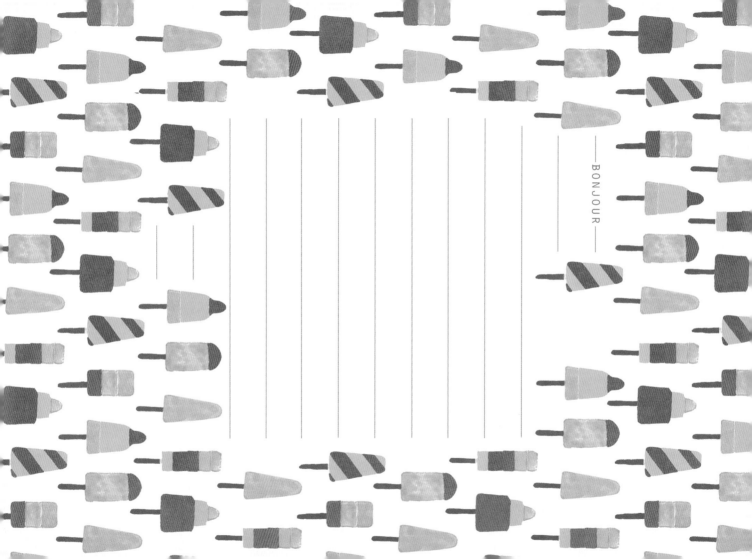

BONJOUR

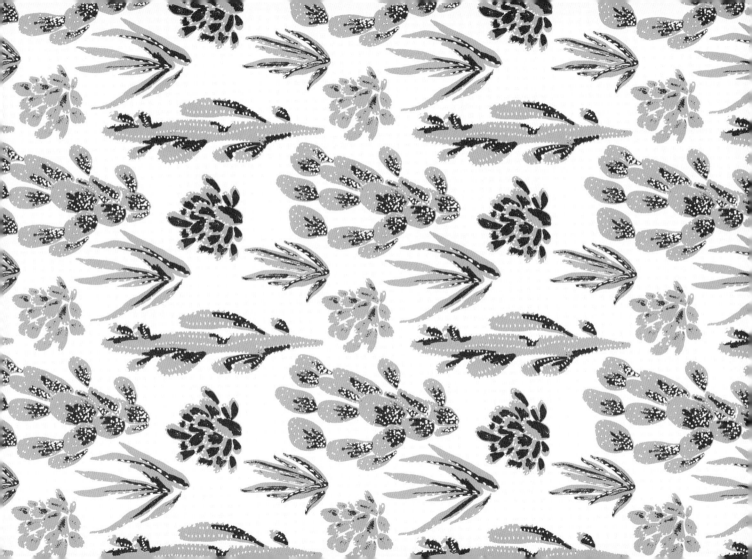

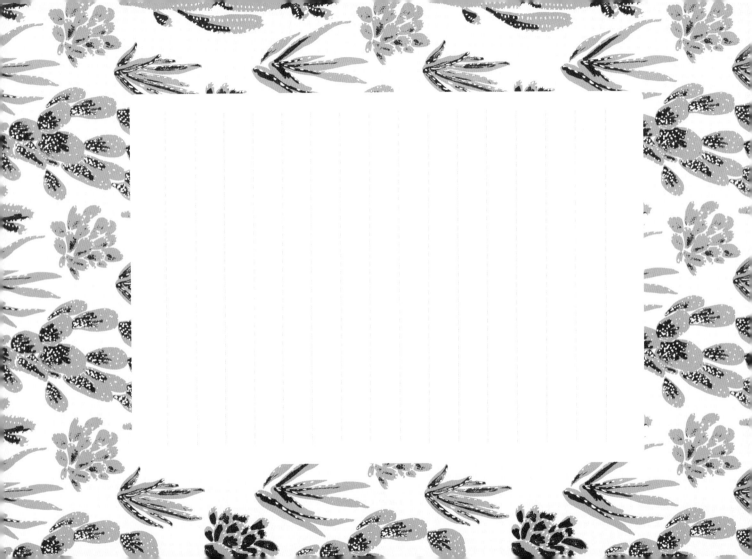

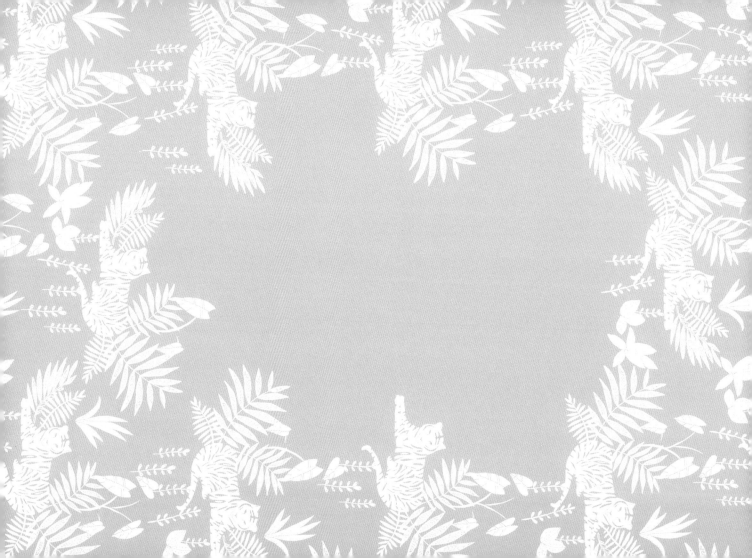

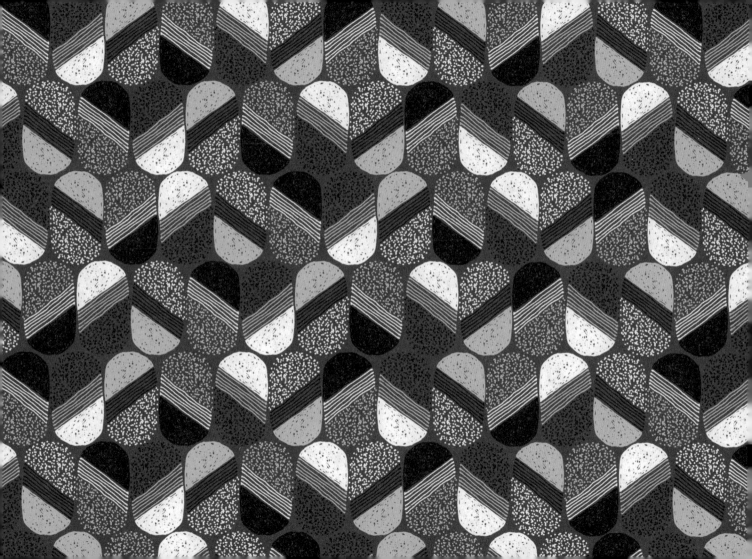

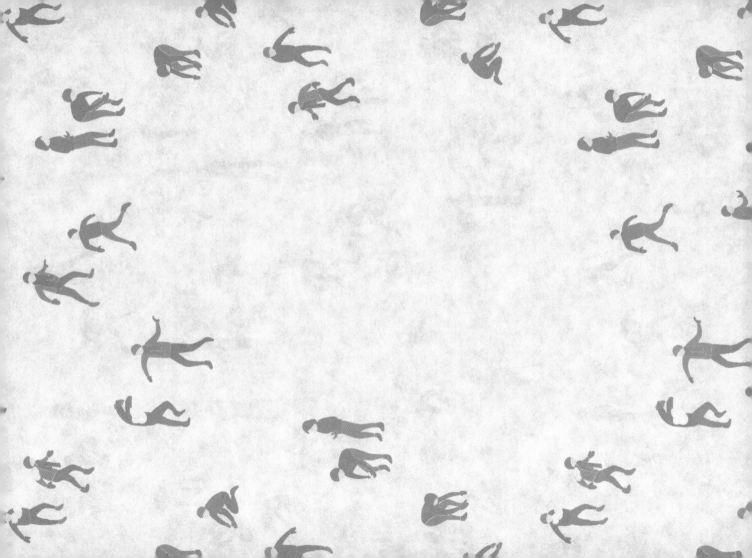

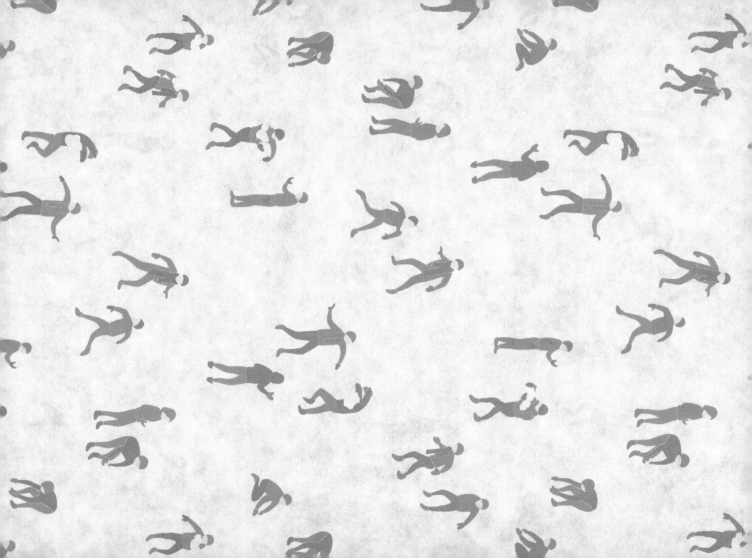

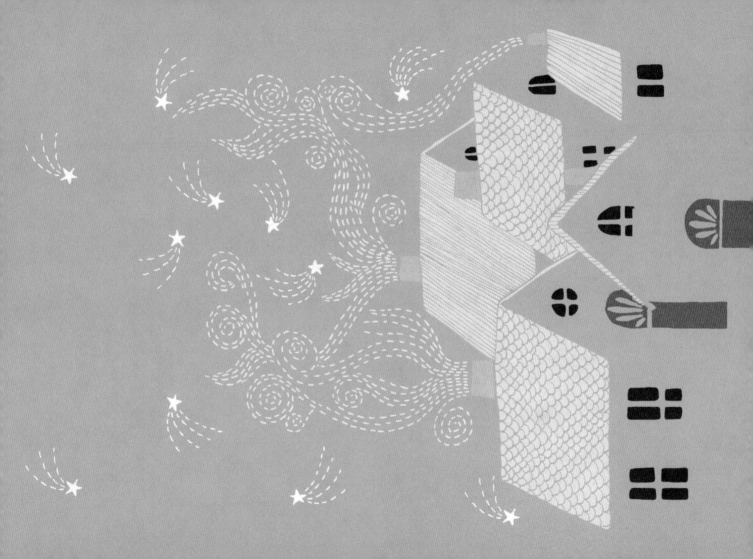

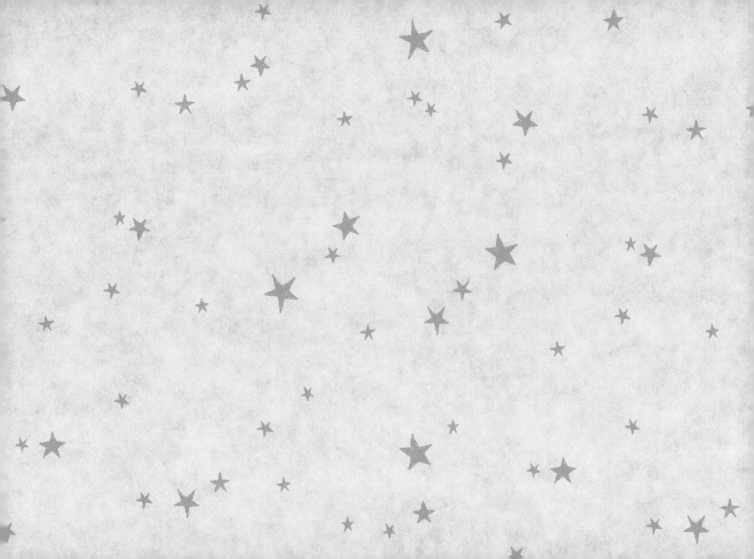

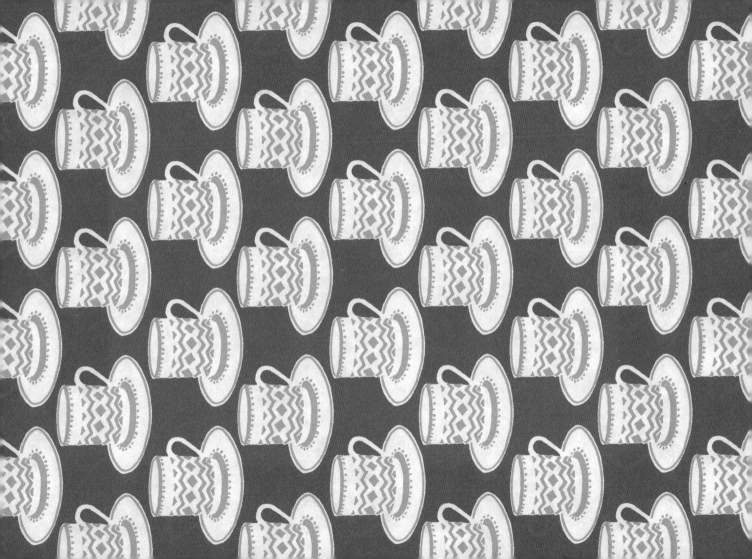

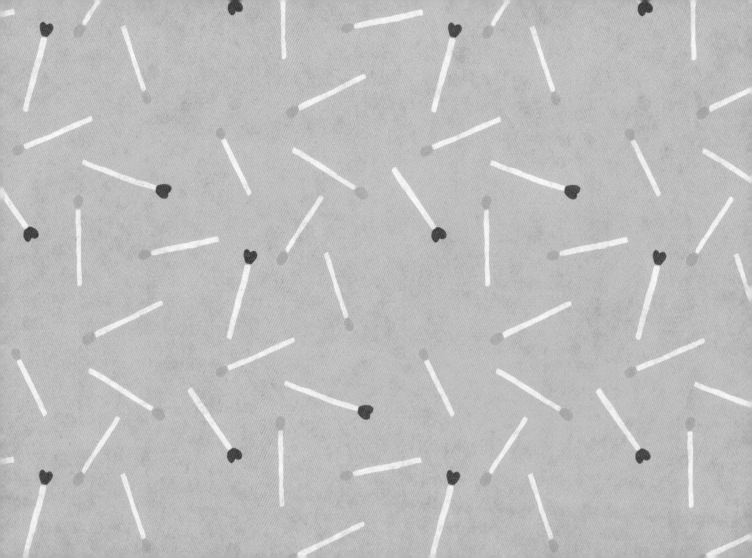

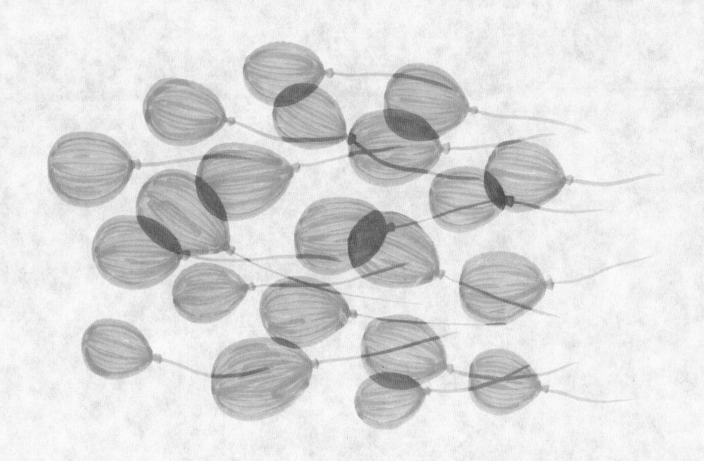

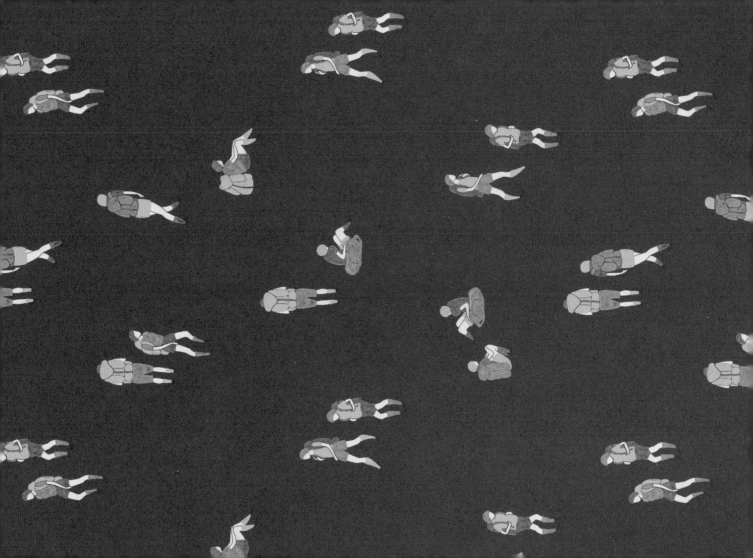

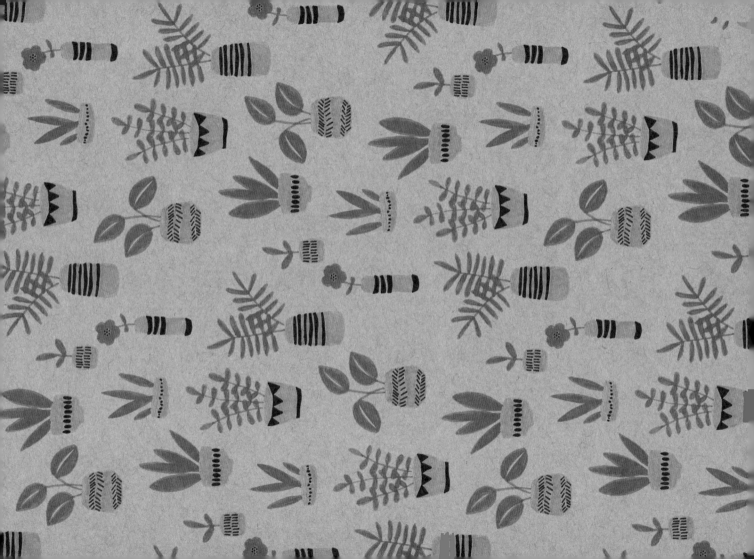

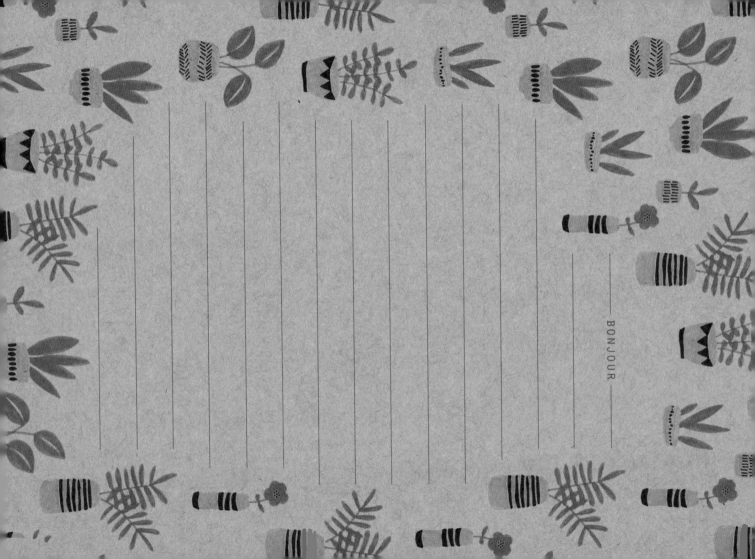

BONJOUR

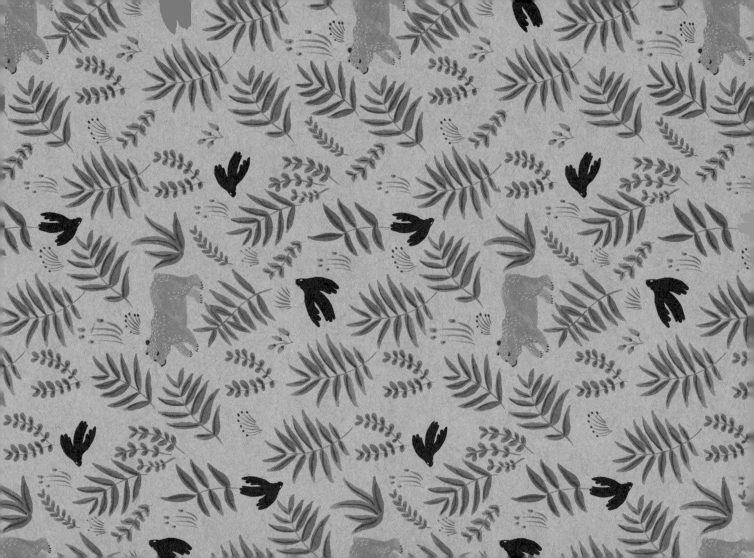

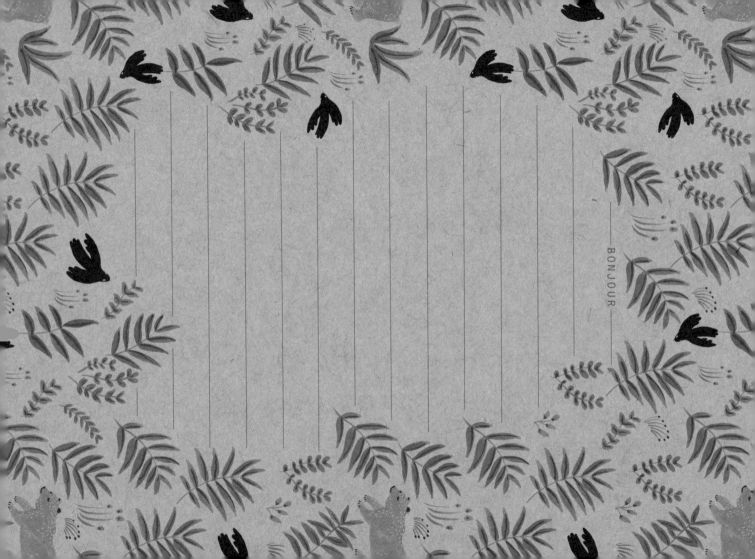

BONJOUR

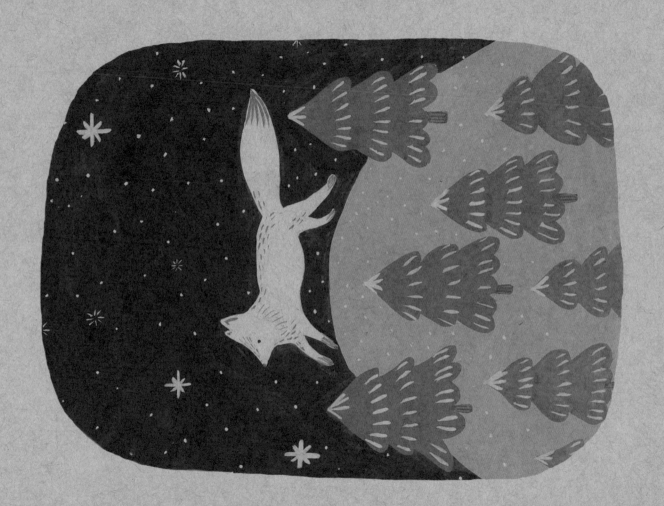

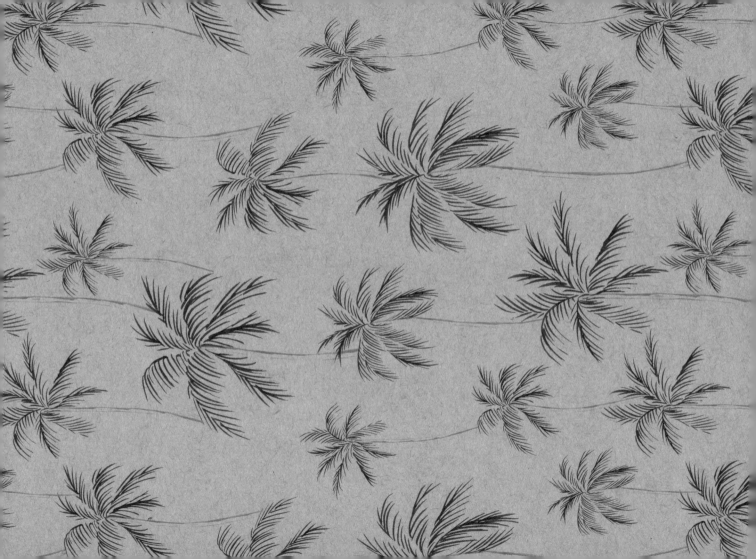

Merci

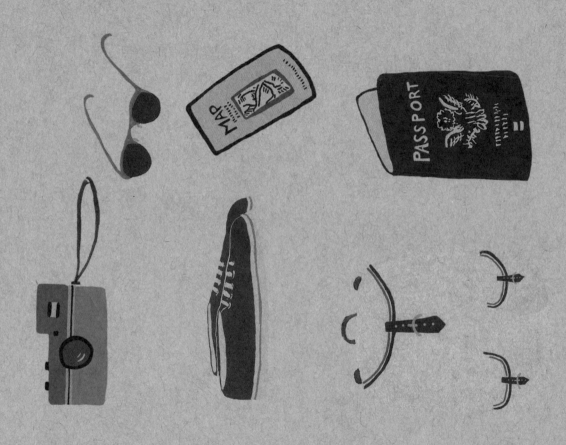

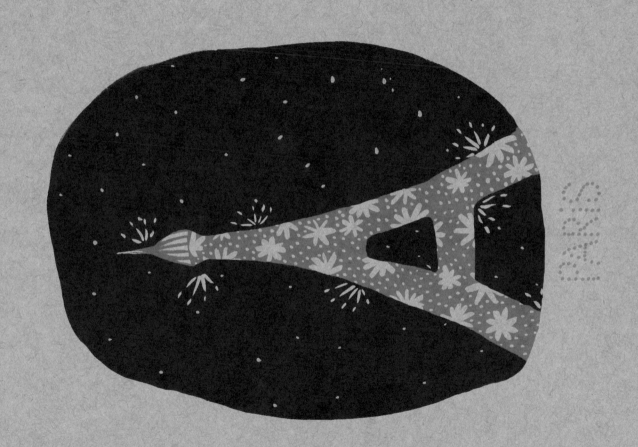

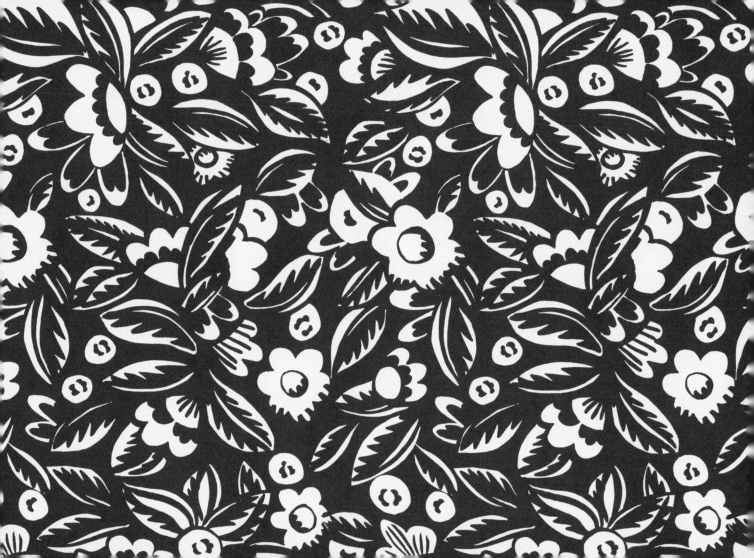

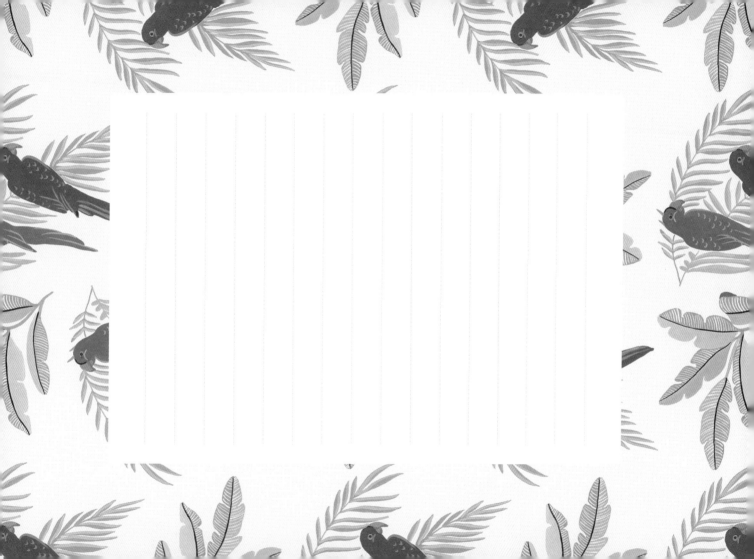

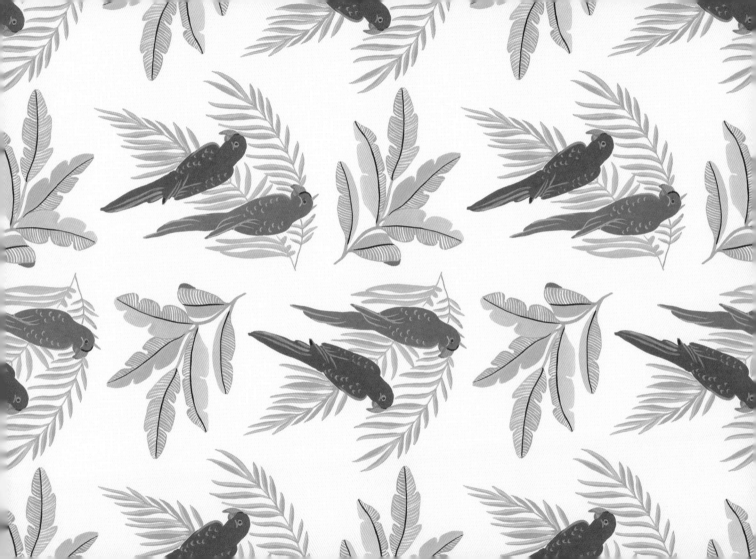

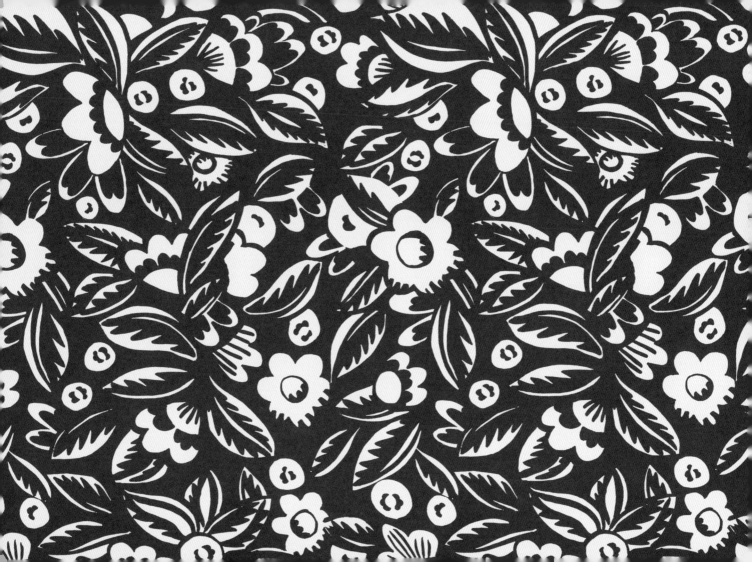

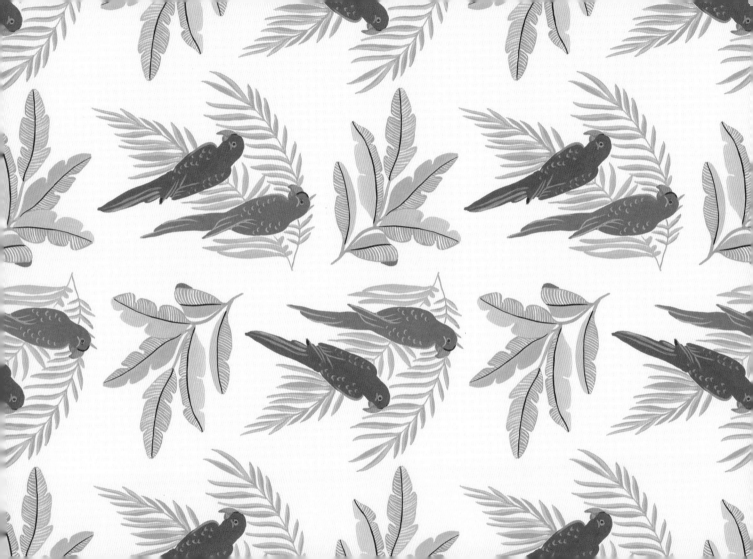